IMAGES
of America

DAVIE

This advertisement from a 1915 issue of the *Miami Metropolis* describes the young community on the edge of the Everglades known as the Davie Farm—"something homelike in that name!" (Broward County Historical Archives.)

ON THE COVER: This Davie entry in a boat parade on the South New River Canal promoted the upcoming Orange Festival and Rodeo in 1949, with Barbara Hammer McCall atop the "horse" and the Orange Blossom Queen contestants on board. (Old Davie School Historical Museum.)

IMAGES
of America

DAVIE

Kimberly Stansell Weismantle

ARCADIA
PUBLISHING

Published by Arcadia Publishing
Charleston, South Carolina

Printed in the United States of America

Library of Congress Control Number: 2021947611

For all general information, please contact Arcadia Publishing:
Telephone 843-853-2070
Fax 843-853-0044
E-mail sales@arcadiapublishing.com
For customer service and orders:
Toll-Free 1-888-313-2665

Visit us on the Internet at www.arcadiapublishing.com

To all those with the foresight to step in and save our history.

CONTENTS

ACKNOWLEDGMENTS

Many thanks to the Davie School Foundation and the Town of Davie for their unrelenting efforts to preserve the Davie School and campus and for building an invaluable keepsake of our history. Thank you to Leslie Schroeder and Barbara McCall for always knowing where to find the answers to all one million of my questions; to Christine McDonough, who hunted down every picture from our archive with a smile; to the friends of Davie who contributed their memories; to my family, who listened to all these stories 100 times. And especially, thank you to Kyle and Lincoln, who remind me why it is important.

Unless otherwise noted, all images included within this book belong to the Old Davie School Historical Museum archive collection. Author proceeds from this book will be donated to the Old Davie School Historical Museum.

INTRODUCTION

Looking at a map of South Florida today, Davie is relatively easy to pinpoint. The majority of the town is nearly corralled by the North and South New River Canals to the north and south and by the major highways of the Florida Turnpike to the east and Interstate 75 to the west—man-made features built in an attempt to take control of the Everglades and carry the people who flooded the area.

For thousands of years, Davie and the surrounding communities would have been unrecognizable, folded in as part of the massive overflow of water from Lake Okeechobee that made its way to the coast through sawgrass and pockets of pinelands and hardwood hammocks. A chain of seven islands stood out from the water as the highest ground in the future Broward County. This landmark, which reached 29 feet above sea level, was known as the Pine Island Ridge. Native peoples of South Florida began to make their homes on these islands more than 5,000 years ago—first the Tequesta, and later the Seminole.

Throughout the 1800s, the Seminole, like many other Native American tribes in the country, were pursued and forcibly relocated to reservations in Oklahoma by the American government. The natural Everglades proved to be an ally for the Seminole, as the water and sawgrass made it almost unnavigable for federal forces. In 1838, US troops under the command of Maj. William Lauderdale marched west from the fort that bore his name along the New River. The 500–600 men were instructed to capture the Seminole believed to be living on Pine Island Ridge. Wading through waist-deep water and pulling canoes carrying their weapons, the troops were ill-prepared for the environment. When they arrived at the Pine Island Ridge, they found the Seminole community deserted. Abiaki, a Seminole medicine man, led the community of around 60 people from the village to safety farther west in the area that would later become the Big Cypress Reservation. Fort Lauderdale was abandoned within three months, and its namesake was dead from pulmonary illness not long after, which he possibly contracted during his travels through the Everglades marshland.

When the federally owned swampland was reverted to the State of Florida under the Swamp Act of 1850, the Everglades were considered wasted space. Over the next 100 years, man would drastically warp and redesign the southern part of the peninsula to exploit the environment for agriculture, housing, and commercial development. This was the final frontier—the last of the unclaimed land in the United States after the West was "conquered."

The state government initiated the Everglades drainage project in the early 20th century and sold the land at inexpensive prices to entrepreneurs, who agreed to continue "improving the land" by building canals and making it habitable and available for development. However, some developers did not follow through, and the land remained underwater. Deceptive speculators sold acres of land sight unseen to buyers, who arrived only to see their property submerged—which led to the coining of the phrase "land by the gallon."

Developer R.P. Davie and his collection of companies with frustratingly similar names—Everglades Land Sales Company, Everglades Land Company, and Everglades Sugar and Land Company—did fulfill promises made to their buyers, laying the foundation for a thriving agricultural community that would soon share his name. The Everglades Sugar and Land Company donated acreage to the Broward County School Board to build the first permanent school in the Everglades, and the Davie School has been in continuous use since its construction in 1918. The community grew to encompass a thriving citrus industry, a unique educational complex, and a desire to preserve the open space that was constantly threatened.

Hardships were inevitable on the frontier. Natural disasters like floods and hurricanes, and worldwide events like wars and the Great Depression reshaped the community multiple times, placing more challenges before the pioneers. In a community with a history of segregation, social changes came slowly—schools were segregated until 1965. In 1978, the town named its newest park for Edna Mae Potter, a local resident and advocate for the Black community in Davie whose work brought a federal grant to build the park, among her other many contributions. The presence of the Ku Klux Klan during this period contradicted the progressiveness of the business and educational center of Davie and tainted the rural nostalgia valued by the community. Like other communities throughout the country, Davie continues to grapple with these issues as it moves toward greater equality and understanding.

Davie's greatest challenge comes from its greatest asset—its determination to hold onto its agricultural heritage while boasting a population that soared over 103,000 in 2019. The balance is constantly being tested in booming South Florida. Virginia Wagner, in her book *The History of Davie and its Dilemma*, writes from the unique standpoint of witnessing impending change in Davie in 1982:

> What is the essence of the Davie spirit? Harry Earle says the settlers had to be gamblers at heart to take on, as many did, this new land sight unseen. They had to be willing to work hard under the most discouraging conditions, to have their work destroyed by storms and wind—then try again. To survive, they had to help each other, especially when in distress. Can this same spirit be kept as the population grows and newcomers arrive who know little or nothing about the community's beginning?

This book seeks to share the history of Davie through photographs and stories, the majority of which were donated during the Old Davie School Historical Museum's early years in collecting for its archive. We are forever grateful for the extensive collection of hundreds of images but recognize the underrepresentation of the African American, Jewish, and Hispanic community experiences in the area. As the Old Davie School Historical Museum works to expand the chronicles of Davie's contentious and storied history, we hope this book will serve as a stepping-stone to inspire further investigation among the next generation.

One

FROM THE EVERGLADES

After Napoleon Bonaparte Broward's successful run for governor of Florida in 1904, he began his pursuit to "drain the pestilence-ridden swamp" of the Everglades. The state-owned property included over one million acres of flooded and wild terrain in the southern Florida peninsula, and the land was much desired to be used for agriculture. The project would change the landscape forever. On July 4, 1906, the first dredge, *Everglades*, worked west-northwest from the north fork of the New River, creating a shipping lane from Lake Okeechobee called the North New River Canal. The dredge *Okeechobee* launched that October, traveling directly west from the south fork of the New River, digging the South New River Canal and spearheading the draining of the Everglades in this region.

R.P. Davie, along with his partner J.R. McKinnie and other investors, formed the Everglades Sugar and Land Company, purchasing 28,000 acres in 1908. They continued the project of building the canals and "improving" the land that became known as the Davie Tract, as well as starting a 10-acre experimental farm. Workers returning to the United States from the Panama Canal project formed the Zona Glade Company in 1911, purchasing and cultivating 700 acres of land in this area. These enterprising pioneers called their new settlement Zona after the Panama Canal Zone.

In January 1913, the farmers organized as the Everglade Vegetable Growers Association, an effort to collectively ship fruits and vegetables to market and provide mutual aid. The association grew to 75 members by October 1913. With weekly meetings held during the prime growing seasons, the association dealt with more than farming troubles—it served as the first governing body in the area—and when problems arose with mail service, the association put forward a solution. The name Zona too closely resembled a city by the name of Ozona in Pinellas County, causing trouble with mail delivery. Therefore, in April 1914, with a resolution adopted by the Everglade Vegetable Growers Association and signed by nearly all residents, the post office formally recognized the new name of the community as Davie.

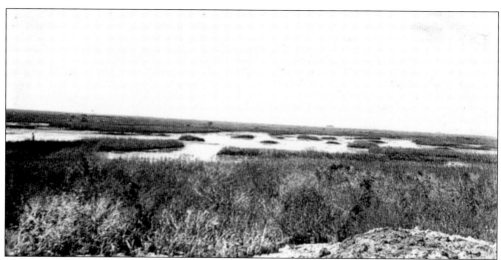

The immense project of draining the Everglades began in 1906. This inimitable environment, shown here looking north from the dredge *Okeechobee*, would soon drastically change as machines carved through the sawgrass prairie. The canal system would ultimately redirect the natural movement of water that, for thousands of years, had flowed from Lake Okeechobee out to the coasts in a slow-moving "river of grass." (State Archives of Florida/Gunter.)

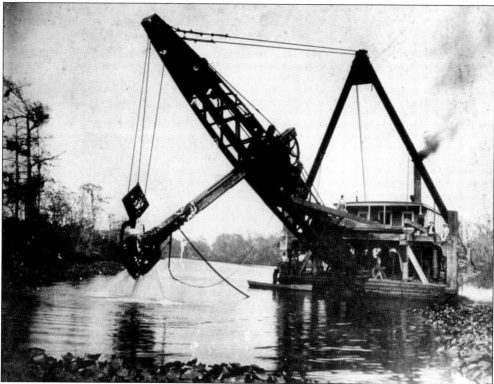

The *Okeechobee* and *Everglades*, along with other dredges like this one, the *Marion*, were dipper dredges. Steam-powered and requiring more than eight men to operate, the bucket on the boom arm dug into the earth underneath the water and moved the material to create the new waterways of the canal system. (South Florida Water Management District.)

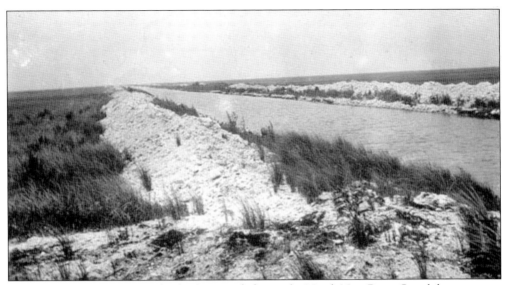

The view looking west from the dredge *Everglades* on the North New River Canal demonstrates how drastically the dredges reshaped the landscape. The canals were 10 to 13 feet deep and 50 to 70 feet wide. Excess material was dumped along the edges of the waterway, creating banks that sometimes looked like high sand mountains and would later become roadbeds. (State Archives of Florida/Sellards.)

In 1912, Lock No. 1 on the North New River Canal began operation—the first lock completed in the reclamation project. The lock controlled the water level and opened travel to the interior of the Everglades, creating access to central Florida in a time before major roads or railroads were in place. Produce and catfish from Lake Okeechobee could now be shipped south on this canal. Lock No. 1 is now listed in the National Register of Historic Places.

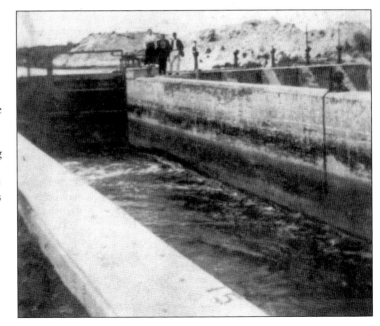

R.P. Davie, a millionaire sugar beet farmer from Colorado, said in a 1913 *Miami Herald* article, "Reclamation and irrigation projects have been a hobby with me for years, and while it is going to cost us a half million dollars to carry out our plans to a conclusion, I propose to play the string out even if it should cost double that. I know what that land is, I know what it will produce, and whenever any land will pay good interest on a valuation of $500 an acre, and do it year in and year out, that land is worth $500 an acre." He closely oversaw the project to drain 28,000 acres of land and the planting of an experimental farm while living in Miami. After merging Everglades Sugar and Land Company with two other companies in 1913, he remained as a director, moving onto another reclamation project in Arizona.

Don't Buy Any Land

Until You Have Investigated Southeast Florida

Where a Few Acres Will Produce as Much Profit as a Quarter Section Elsewhere

You—pale-faced city dweller—employe of other men—slave to the routine of the office—the factory—fearful of the future for yourself and your family—without capital—without resources—whose life is one long struggle with fear of what the coming day may bring forth—do you want to become one of the most independent and fearless men alive?

You—thrifty possessor of hard-earned savings—do you wish to make a small investment which will insure you peace and security for the remainder of your days?

You—hard working farmer, wresting a precarious living from the tough soil and rigorous climate of the North or West—do you wish to exchange your lot for a far easier, safer, happier one?

If you do, investigate Southeast Florida and the Everglades. Learn the facts in regard to the most wonderful home land on the earth's surface. Then try to match these facts—if you can.

You don't need to work two hundred or three hundred acres in the Everglades, as Northern and Eastern farmers do. You don't need to pay $500 an acre, as many buyers of irrigated land do in the West. You don't need to wait until you accumulate a bank account to acquire some of this land—a secure income—future safety for your family—peace, happiness—all that makes life worth living.

Learn about Southeast Florida—Florida, the paradise of the world—Florida, the home of the farmer who is both small and prosperous—small in the amount of his investment and land, and prosperous in his income—Southeast Florida, the land where nature smiles to make men happy.

Don't buy land in Florida yet! Don't buy land ANYWHERE yet! BUT LEARN THE FACTS ABOUT SOUTHEAST FLORIDA! Investigate! Compare what the Southeast coast of that marvelous state can offer you with the best that any other district in the world can offer you. Then make your own decision. But before you decide on any purchase INVESTIGATE SOUTHEAST FLORIDA AND THE WORLD-FAMED EVERGLADES.

Send for our big 48-page booklet today; then plan to join our next excursion and make a first-hand inspection of this wonderful new agricultural empire.

Visit the South Florida Exhibit, East End of Main Aisle, Coliseum, and Ask for Our Salesman

Additional Facts About Dade County and the Everglades

Did You Know—

1 That a Governor and a U. S. Senator were elected on the issue of "Reclaiming the Everglades"?

2 That the drainage district comprises a territory nearly as large as the state of Massachusetts—equal to the area of Rhode Island, Delaware and Connecticut combined?

3 That the Everglades are an elevated plateau with a gentle slope from Lake Okeechobee to the sea, having an average fall per mile which is greater than from Lake Superior to the Gulf of Mexico?

4 That the Everglades are in reality a prairie, almost entirely free from trees?

5 That Lake Okeechobee, at the northern end of the Everglades, is the second largest lake entirely within the boundaries of the United States—second only to Lake Michigan?

6 That the drainage was pronounced feasible and simple by army engineers as far back as 1849?

7 That nine giant dredges are now working day and night to complete the reclamation at the earliest possible date?

8 That drainage of wet lands costs only a fraction as much per acre as irrigation of arid lands?

9 That the Everglades district is the only part of the United States where tropical fruits can be raised?

10 That fruit-killing frost there is so rare as to be almost unknown?

11 That tropical trees and fruits, like the mango, avocado, papaya, banana, etc., thrive and can be raised commercially in this district?

12 That citrus fruit trees come into profitable bearing sooner on Everglade soil than on pine land?

13 That the Everglades offer an opportunity for the culture of a greater variety of products than perhaps any other section of the United States—71 varieties of fruits and almost every vegetable known to man?

14 That the Everglades enjoy perhaps the most equable climate in the world, varying only 17 degrees during the entire year between the average maximum and average minimum temperatures?

15 That 96 degrees is the highest temperature ever recorded, and that there are fewer hot days over 90 degrees in the Everglades than in most Northern cities?

16 That the Everglades lie in the only part of the United States that is encircled by the Gulf Stream?

17 That the Everglades are nearer to the Panama Canal than any other part of the mainland of the United States?

18 That this district has a continuous growing season—365 days in the year—and its crops are among the first to reach the great markets?

19 That this section is 1,000 to 1,500 miles nearer the great markets than its only competitive state?

20 That the Everglade soil is exceedingly rich—principally a black muck and alluvial deposit, altogether different from the ordinary sandy pine land of Florida?

21 That an Everglade acre ought to produce, under intelligent cultivation, from $200 to $1,000 and upwards yearly?

22 That 500,000 acres of the Everglades, when drained and planted to sugar cane would produce the 3,246,068 tons of sugar, valued at $157,224,760, now imported yearly to the United States?

23 That sugar cane allowed to stand until February or March before harvesting makes a higher sugar content, and that this can be done in the Everglades without danger of freezing, and that this is impossible in the other Southern states?

24 That ten acres in the Everglades can be made to produce more profit than the average large farm in the North?

25 That more than 40,000 ten-acre farms in Southeast Florida have already been sold to Northern, Eastern and Western buyers?

26 That the land which we are now offering you is a part of the original big sale by the state, the proceeds of which furnish the first real money for the drainage operations?

27 That the Everglade Land Sales Company controls 70,000 acres of the best located land in the Everglades?

28 That this Company will expend not less than $250,000 improving its lands for the benefit of the buyers in constructing secondary canals, lateral ditches, etc.? Some of these improvements are already under way.

29 That Dade County roads are among the finest in the country, making carriage or auto rides indeed a pleasure?

30 That the Dade County schools rank foremost in the state?

31 That you could indulge in all the outdoor pleasures, such as boating, fishing, hunting, bathing, etc., which pleasures thousands gladly pay the price of a farm for every year and think their sport royal and well worth the money?

32 That we will operate a demonstration farm for the benefit of our buyers?

33 That the population of Dade County during the last decade increased 14 times the average for the United States?

34 That winter time in the Everglades is like June time through the North and West?

35 That South Florida raises and sells many products in winter at hot house prices?

36 That South Florida oranges contain 41% more juice than oranges raised elsewhere?

37 That a wage earner can buy a farm here, paying for it out of his monthly earnings?

V. W. HELM, General Sales Agent, **Everglade Land Sales Co.** **1226 Majestic Bldg., CHICAGO**

50,000,000 people must get their fresh winter vegetables from South Florida

Newspaper advertisements around the country, like this one from the Chicago *Inter Ocean* in 1911, inspired buyers with the economic possibilities of the reclaimed Everglades farmland. The Everglade Land Sales Company advertised 37 facts about southeast Florida, including how "wintertime in the Everglades is like June time through the North and West." It detailed amenities like its schools, roads, and "outdoor pleasures, such as boating, fishing, hunting, bathing, etc." It also highlighted the 10-acre experimental farm on the Davie Tract—a "demonstration farm for the benefit of our buyers." Early pioneers came from Illinois, Iowa, Kentucky, Michigan, and even Canada, Estonia, and the Panama Canal. Prices started as low as $2 per acre but quickly grew to between $10 to $50 per acre. (University of Illinois.)

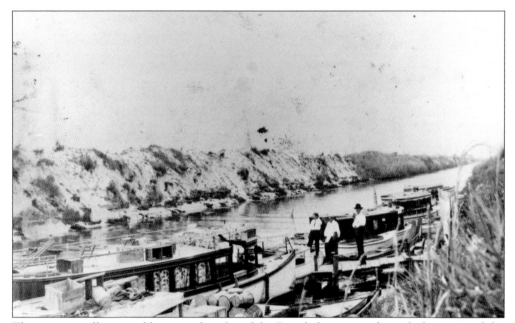

The growing collection of farms on the edge of the Everglades attracted people from around the world—some as visitors to the spectacle of the drainage project, others as prospective buyers. Here, boats are docked along the canal in the early 1910s. Realty companies offered free trips from Fort Lauderdale to see the land, even providing educational speakers and live music on board.

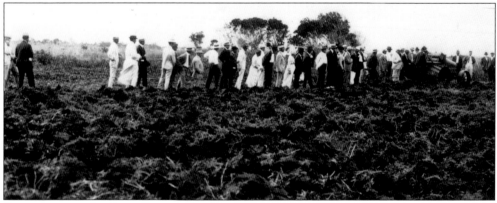

Groups touring the Davie Experimental Farm saw the black muck soil and tools used on the farmland, such as this tractor. Among one early group was William Hammer, who visited three times from Alberta, Canada, before purchasing his property and moving with his wife, Adeline, and 11 children across the country in 1913.

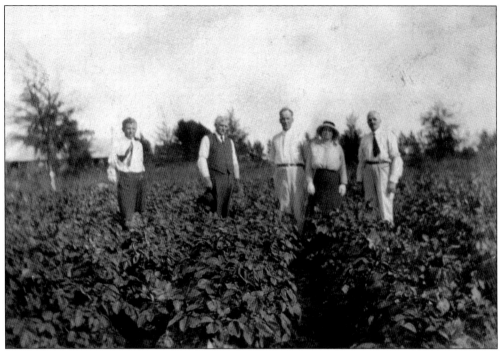

In 1911, R.P. Davie ordered the planting of 12,000 grapefruit trees as the first test of citrus in the muck soil. The Davie Experimental Farm tested the success and profitability of crops, including sugar, cotton, tobacco, potatoes, and other vegetables. These visitors are touring rows of thriving pepper plants in 1917.

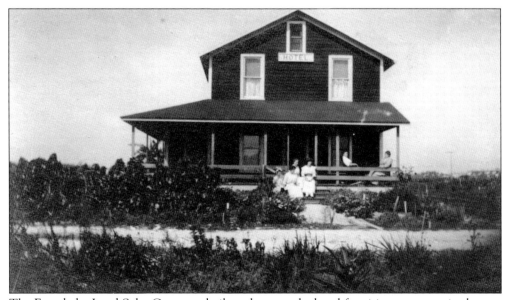

The Everglades Land Sales Company built and operated a hotel for visitors, prospective buyers, and men working on the dredges. Built in 1911, the building has served as a hotel, restaurant, the first women's club building, and a barbershop, and currently houses private apartments on Sixty-Fifth Avenue and Griffin Road.

Everglade Tomatoes Solid Hand Packed

By the Zona Glade Company

These Tomatoes are fresh from the Everglades and packed in 20-ounce cans under the personal supervision and care of the Zona Glade Company exclusive sale by

Everglade Grocery Company

Fort Lauderdale, Florida

After purchasing Everglades land sight unseen from a salesman in Panama, workers returning to the United States from the Panama Canal project organized and formed the Zona Glade Company in 1911. The company farmed a 700-acre tract and built a canning factory, as advertised in the *Miami Metropolis* in 1912. (Broward County Historical Archives.)

Harry Edward Earle worked for the Isthmian Canal Commission in Panama as a supervisor on the canal project and married Panamanian bookkeeper Adolpha Laurence. They arrived in South Florida in May 1911; Adolpha gave birth to their only son, Harry Adolpho, a month later. Earle started the Davie Mercantile Company, which carried staples for the pioneers, and served on the Davie Farm Sub-Drainage District Board of Supervisors.

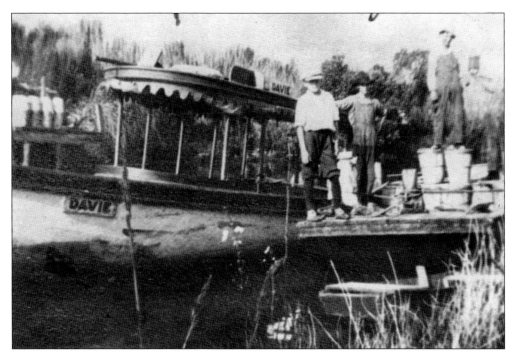

William Alfred "Al" Griffin arrived in the Davie area from Kentucky in 1909 with his parents and brother T.M. The brothers helped start their family farm and ran a boat service from Zona to Fort Lauderdale. Al also worked as a land surveyor; he met his future wife, Anna Dolores Zanetti, when he took refuge on her porch during a storm while surveying.

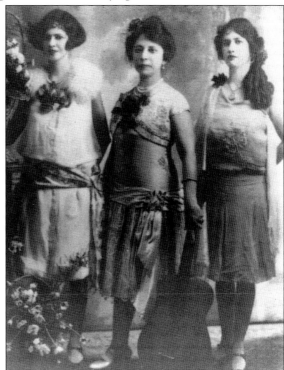

Anna Dolores Zanetti, pictured on the right with her sisters Elida and Karima, arrived from Panama in 1911, traveling with her mother, sisters, and aunt Adolpha Earle. Although Anna Dolores only spoke Spanish, she offered Al Griffin a glass of water when he was caught in the rainstorm, and their romance began. In 1913, they became the first couple to marry in Zona.

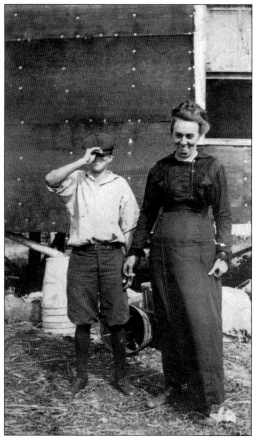

Tar paper homes provided quick and easy shelter for early pioneers. These were constructed with a wooden frame and covered in water-resistant tar paper. The shelters were a temporary solution as new farmers tested their success in the reclaimed farmland. Other early farming families lived in canvas tents; some only stayed seasonally. The Hill brothers—Harry, Will, James, and Thomas—and their sister Martha visited the Davie farmland in 1909. Harry Hill purchased 10 acres of land for himself and for each of his siblings, but life on the frontier was not desirable for Harry and Will's families, and they returned to Michigan. At left, Eliza Hill stands in front of a tar paper home with her son Thomas Jr. The home was raised on pilings in preparation for the inevitable flooding in the Everglades.

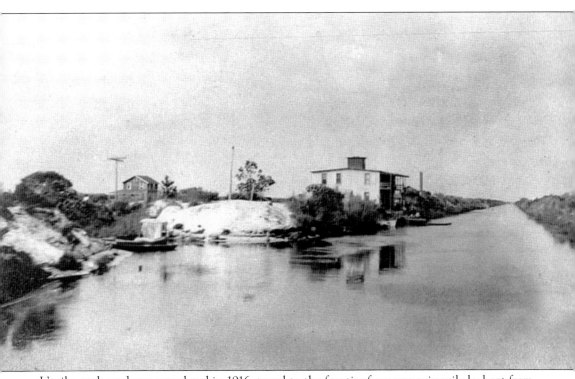

Until a rock road was completed in 1916, travel to the frontier farm was primarily by boat from Fort Lauderdale. Traveling west via the South New River Canal meant passing pinelands, the high sandy banks of the canal, and small homesteads set apart from each other. Few landmarks pointed the way until the Davie Tract and Ingall's General Store with its dock on the bank of the canal. This area is just west of today's intersection of Griffin and Davie Roads. This view looking southwest from the store shows the hotel. The white bank in the center of the photograph led to a lateral canal—a smaller ditch that provided drainage to properties off the main C-11 canal.

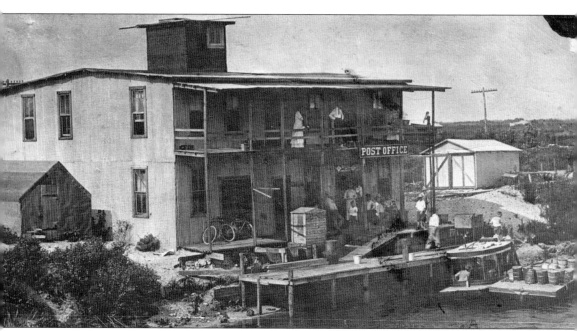

Built in 1911 by Hallandale groceryman C.E. Ingall, the general store provided supplies for the small community. Farmers brought vegetables to this main dock to be loaded onto boats and taken to the Fort Lauderdale market by a broker through the Everglades Vegetable Growers Association. The store also served as the first post office. Until a school building could be constructed, one room of the store was used as a classroom with one teacher. The store changed ownership through the years. By 1923, Edwin Middlebrooks from Georgia purchased it. He and his family made their home on the second floor. With no indoor plumbing, they avoided the chore of hauling water up the stairs by extending the pump to the second floor. The store sustained damage in the 1926 hurricane and was torn down by the 1930s.

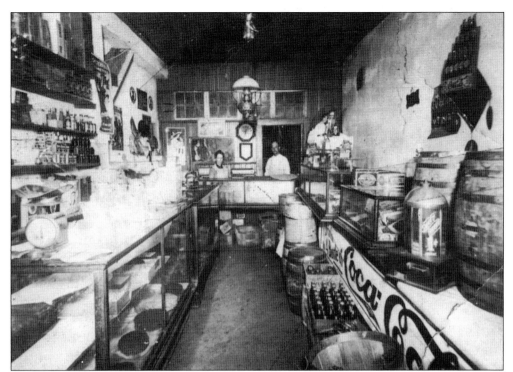

The Middlebrooks store offered dry goods like sugar, flour, and coffee, as well as special items like a bottle of Coca-Cola for 5¢. Other items could be ordered and brought by boat from Fort Lauderdale. The Sears, Roebuck, and Company catalog was another popular means of getting supplies like clothing, tools, toys, and medicines—even automobiles and houses were available.

The Seminole traded fish and meat for goods at the general store, building a relationship with families in the frontier community throughout the years. Seminole people worked on the farms, and the children played together. Pictured here are Seminoles in traditional patchwork clothing on the porch of the store.

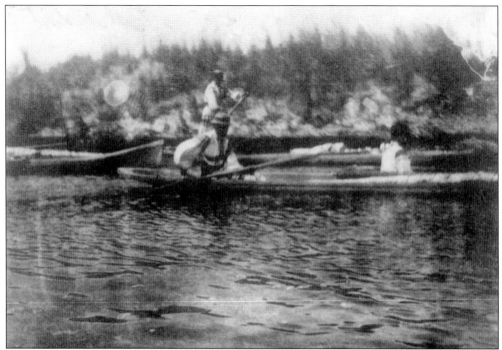

Seminoles traveled the Everglades in dugout canoes built from cypress trees. Using a long pole to propel the boat forward through the shallow waters, they were able to navigate the sharp sawgrass. The newly dredged canals created more access between the Everglades and Fort Lauderdale, with Zona and the Davie Tract in between, as development began to move into the reclaimed land.

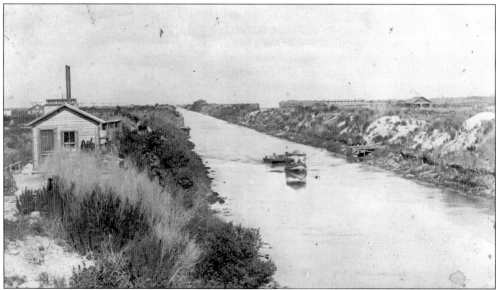

As many as 150 visitors in one week arrived by boat on the canal in 1913 to tour the experimental farm. Flooding issues deterred some of the early farmers, who left their land, but others quickly took their places. In 1914, the Davie Farm Sub-Drainage District was formed—the first district of its kind in Florida—and became responsible for maintaining the canals and dikes, allowing for continued growth over the following decades.

Two

At Home on the Frontier

Whatever reason newcomers chose Davie—for the inexpensive farmland or the health benefits of South Florida, as advertised by salesmen across the country—taking the risk on reclaimed land in the Everglades was just the first step in starting a new life. People began arriving as early as 1909 to begin the work of preparing their land for farming and making it home.

Building on a former sawgrass prairie meant supplies were scarce. Materials for construction were shipped down the canal by barge. Laborers came from Fort Lauderdale, or families built their homes themselves. The structures were raised to avoid floodwaters and allow air to flow through and around the homes in the hot subtropical climate. Wells were driven more than 50 feet into the ground—to the Biscayne aquifer—for fresh water that could be used for drinking, cooking, and washing.

Arriving on the frontier meant encountering native Florida wildlife. Homesteads with domestic livestock like cows, chickens, and pigs contended with wild predators and insects. With American alligators common and venomous snakes camouflaged by the soil and grasses, perils were ever-present. Mosquitoes were a nuisance, lingering in thick droves before the introduction of insecticides. However, this same wild environment provided ample hunting and fishing opportunities for sport and provision.

Families adapted to the Everglades and South Florida enough for Davie to become a sought-after destination by the 1940s. Although hurricanes and floods would strike unforgivingly and force the community to rebuild, the people of Davie endured.

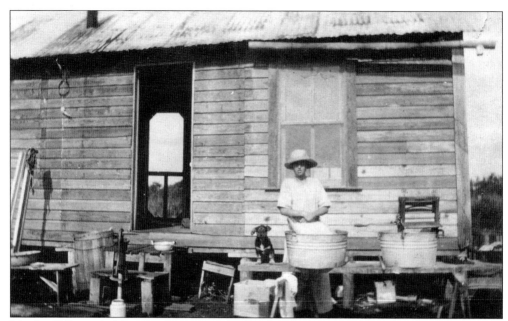

Martha Hill traveled from Michigan with her brothers and their families in 1911. They built two raised wooden houses, but a flood in 1912 caused them to load their furniture onto a barge and wait for the waters to recede in Fort Lauderdale. Here, Martha washes laundry with a washboard and wringer. The windows of the home are screened to allow for airflow and to keep out mosquitoes at night.

After marrying in 1913, Al and Anna Griffin had eight children. Al worked as a carpenter and built a houseboat so he could tow his family along wherever he worked between Davie and Fort Lauderdale. In 1922, the houseboat was dry-docked permanently along the canal and eventually moved onto their property with additional rooms added. As seen here, the high windows and low roof are the only hints of the structure's previous life on the water.

Hamilton and Blanche Collins Forman lived in a tent along the North New River Canal in 1910 until they could build a home from sturdy Dade County pine. They started a successful potato farm and served as the first lockkeepers of Lock No. 1, befriending travelers passing on the canal, including members of the notorious bank-robbing Ashley Gang. Supplies were brought by boat from Fort Lauderdale, but keeping chickens provided the Formans with meat and eggs. At right, Blanche tends the chickens grazing along the canal bank. Below is Blanche with her shotgun holding the alligator she caught in her chicken coop. She became a skilled shot on the frontier and most likely enjoyed this alligator's meat for dinner. Note the appreciative chicken silhouetted in the background beside the chicken coop. (Both, Broward Historical Commission.)

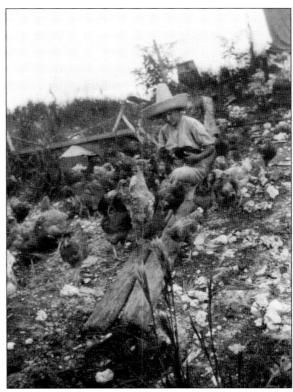

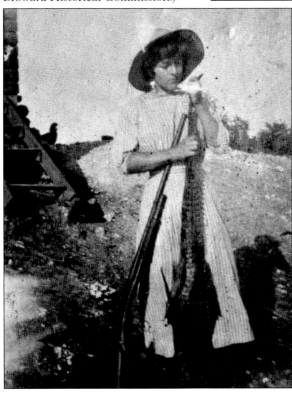

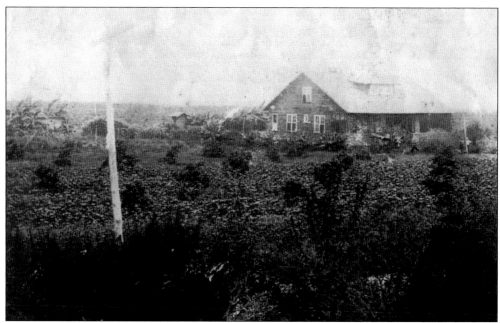

After Harry Viele spent several years working in mining in South America, he returned to Seattle, Washington, with his wife, Helen, and son Charles Edward. He had lung troubles, and his doctor recommended humidity like that in South America, so Harry settled on South Florida. In 1910, he purchased 30 acres; two years later, he had the family home built with modern conveniences—including an indoor bathroom—for $3,000. The home was raised almost five feet, and when the original gable roof of the house (above) blew away in the 1926 hurricane, they were able to save the rest of the home and rebuild with a hip roof. Below, Harry and Helen Viele stand in front of their updated home.

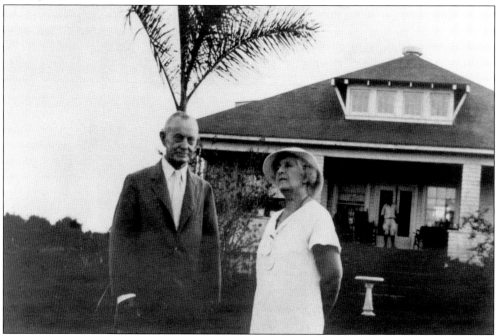

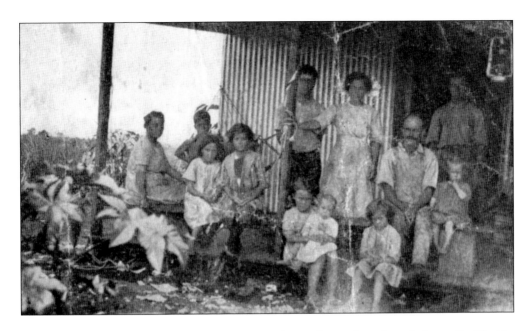

In 1913, the Hammer family of 13 traveled by train from Alberta, Canada, to Jacksonville, Florida, boarding a paddlewheel boat there to journey down the coast to Miami. They took two touring cars to Fort Lauderdale, while Paul, the second oldest son, rode the family bicycle. They stayed in a hotel before moving into a tent beside the hotel. William Hammer and the older boys built a home in Zona, and the rest of the family soon followed. They arrived by boat down the South New River Canal to a dock shared with the Hill families, loaded their belongings onto a smaller rowboat pulled by their new horse, and continued the half mile down a lateral ditch to their home. Above, the family sits on the porch of their three-bedroom home, built with a wooden frame and corrugated tin siding. Below are six of the Hammer children (from left to right): Norma, Arline, Alma, Clifford, Ralph, and Wally, with their horse Nellie.

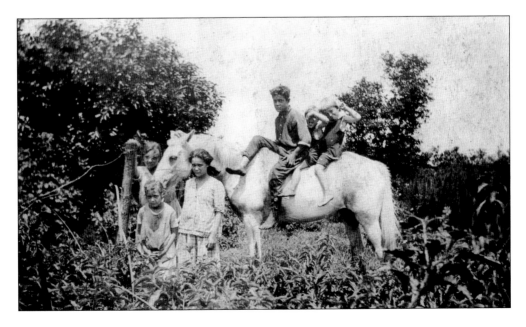

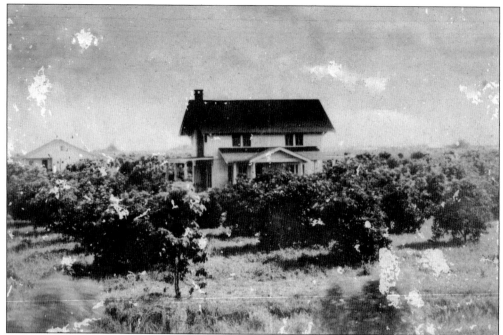

Charles and Katherine Walsh moved to Davie in 1914, purchasing their home from the Aladdin Houses catalog. The kit home cost $940, including everything needed to build it—including lumber, floorboards, windows, and two coats of paint (for inside and outside). Katherine was Helen Viele's sister, and they lived only a half mile apart at their Davie properties. The Walshes started Wacico Groves on the land surrounding their home.

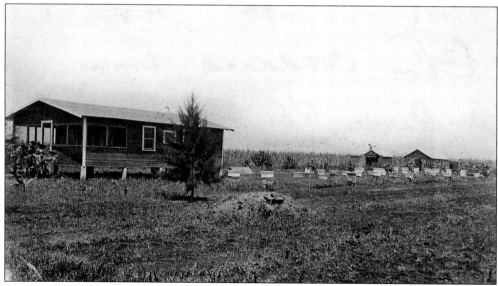

Charles Stoddard was among the group that returned from the Panama Canal with the Zona Glades Company in 1911. Along with a vegetable crop from his farm, he began keeping bees in 1912, starting with only 2 beehives that grew to 50 in three years, as shown in this 1915 photograph. The profitable hives brought in two crops of honey each year.

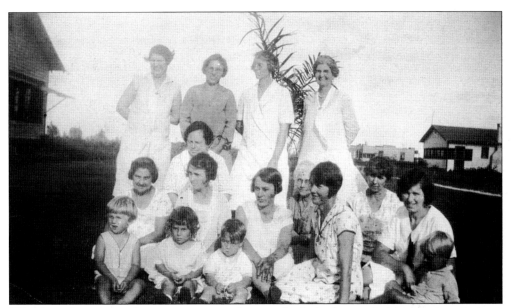

While most homes were far apart on separate farmsteads, the background of this photograph shows rows of neighboring houses. Some of the farms, and later dairies, provided housing for workers and contained a mixture of rented and owned homes. The 1930 census marks this area as "No Street, No Number," though it is roughly in east Davie today.

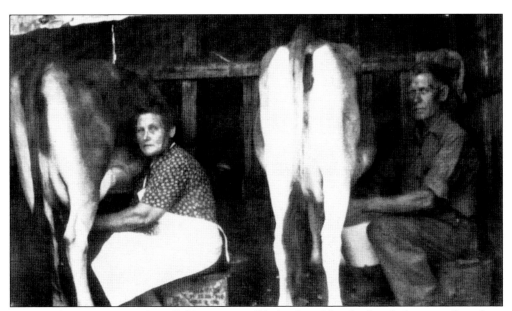

In 1912, Gustava Vinupu Saar (left) a native of Finland, and her husband, Augustus Saar from Estonia, moved their family to a tent on the Davie farmland. When Augustus died from a stroke, Gustava managed the farm and children on her own until she married Joseph Tully (right), who had also immigrated from Estonia, in 1920. They farmed in Davie until moving to West Palm Beach in 1932 when they claimed, "Davie was becoming too crowded."

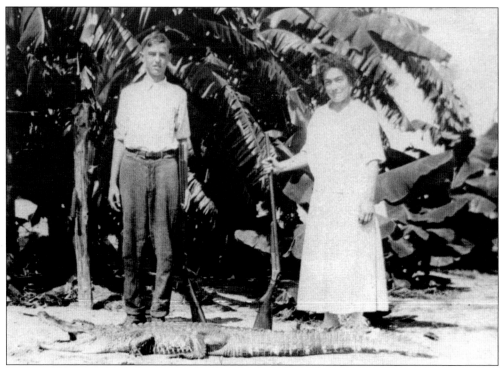

Raynold Saar (left) was one of the first children born in Davie, to Augustus and Gustava Saar in 1914; he is shown as a teenager posing with an alligator. A common predator of livestock in the Everglades, alligators were hunted for their profitable skins that could be tanned and traded or sold at the market in Fort Lauderdale.

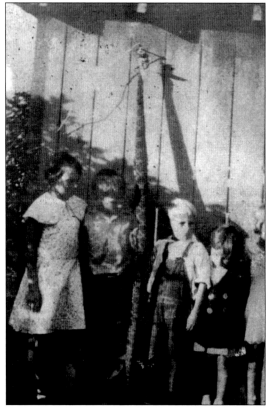

To protect against camouflaged venomous snakes, children were warned to walk together in groups and carry a big stick to shuffle the grass ahead of them. Here, from left to right, young children Arlene Achemire, unidentified, Robert Wabnitz, Frances Wabnitz, and Bernadine Wabnitz stand beside a six-foot Eastern diamondback rattlesnake caught on the side of a canal in Davie in 1929.

While the canals changed the Everglades from a balanced, waterlogged ecosystem to open farmland, the agriculture painted a new landscape. Banana trees, like those pictured in the background here, were introduced as a source of income on farms as they were inexpensive to plant and maintain—some farmers used seaweed they brought from the coast as fertilizer.

Clara Hammer is standing on a makeshift bridge over a ditch on her family property. On a January day in 1917, while the family worked on the farm, Clara was helping to prepare lunch when her mother, Adeline, became sick. Clara called in the doctor from Dania, as there were no doctors in Davie. When the family returned that evening, they found Adeline had delivered her 12th child—they had not even known she was expecting.

When Frederic Clay Bartlett—an artist known for Bonnet House, his beachside estate in Fort Lauderdale—was looking for a rural retreat, he purchased five acres in Davie in 1940. The home was designed after a Bavarian hunting lodge Bartlett had visited on his travels, and he kept many of his art pieces at the country estate. The home remains near Davie Road today as part of St. Joseph Catholic Church.

Many of the older homes built from wood did not survive the hurricanes and floods during the early decades of the community. After the 1947 flood, Ed Hammer, the oldest son of the Hammer family, built his home from poured concrete on Griffin Road, where it remains today.

Three

A GROWING INDUSTRY

The success of the Davie Experimental Farm brought new farmers from around the country and globe to the Everglades. Truck farming, or farming for sale at market, became the first major industry in the new community. The 1920 census reports 190 residents in Davie—of the 64 men between the ages of 18 and 79, a total of 53 reported their occupation as truck farming. Other occupations included carpenters, two cattlemen, two grocerymen, a bridgetender, two schoolteachers, and one veterinarian.

By the time of the 1930 census, the population had more than doubled to 426, and occupations were diversifying. With a variety of jobs, including carpenter, grocery retail, dredge work, a "cold drinks merchant," a clergyman, a housepainter, a school-bus driver, and the school principal, among many others, the community remained centered around agriculture, with 58 percent of the working men older than 18 involved in the truck farming business. The next two most popular industries were dairy and citrus, which offered opportunities that would surpass the truck farming business in Davie over the next 20 years. Women's work also expanded outside of the home, with women working in the dairies and in retail jobs such as "dress goods saleslady." Some women also worked as laundresses, often from their own homes.

A small but growing community of African American families also arrived in Davie during this early period and found jobs on the farms and dairies and in domestic work. The census, however, does not account for seasonal laborers, particularly from the Bahamas. Men and women from the Bahamas traveled to South Florida to work in agriculture during the farming seasons. A 1945 *Miami Herald* article reported that 75 Bahamian workers were already employed in the citrus business and 125 or more would likely be hired during the summer.

The community in Davie continued to evolve as the people and landscape changed throughout the 20th century.

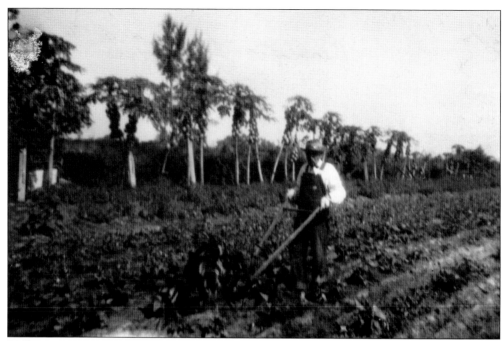

William Hammer uses a hand plow to till his cabbage field in the late 1910s. The tall row of trees in the background are papaya trees that provided fruit as well as a windbreak to protect the vegetable field. Tropical fruits like papaya, guava, banana, and avocado were frequently grown in Davie's year-round warm climate.

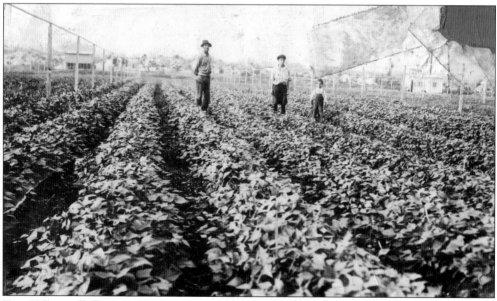

Tom Hill installed an overhead irrigation system on his bean farm in 1911. The system of pipes brought water from the lateral canals and main canal over 10 planted acres. The management of water moving through the canals, dikes, and pumps would become the greatest issue in the Everglades farmland over the course of the 20th century.

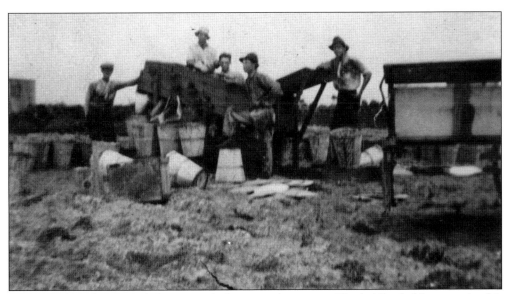

Potato-grading determined the price of a hamper of potatoes. The half-bushel hampers in this photograph each held about 30 pounds of potatoes. After harvest, the potatoes would be checked for size, shape, and any defects. According to a 1914 *Miami News* article, a well-shaped potato would be designated No. 1 and sell for $1.50 per hamper, while a less appealing No. 2 would sell for $1.25.

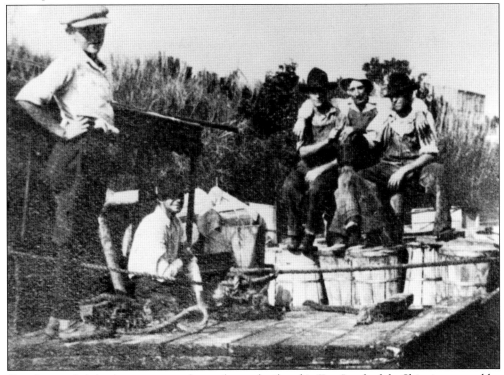

Canals provided the main routes to the market and railroad in Fort Lauderdale. Shipping vegetables by boat required hampers and baskets to be loaded onto barges at the general store dock on the South New River Canal, as shown here. Vegetable brokers operated as middle men between farmers and the market, shipping the produce around the country.

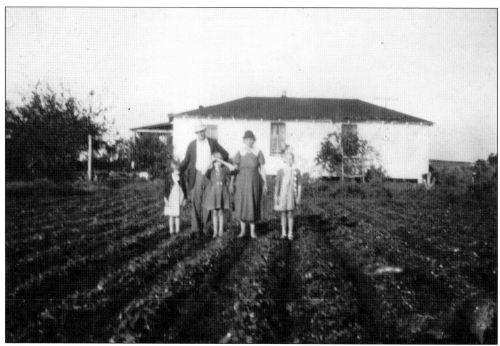

Carl Johnson, originally from Sweden, worked as a steelworker in Cleveland, Ohio. When a sign in a realty office window caught his attention, he purchased 10 acres of land sight unseen in the Florida Everglades without any farming experience. He moved his family to Davie in 1911 and began truck farming—he is shown above with his family in their strawberry field. In a *Miami Herald* article from 1923, Johnson stated that in his best season in 1919, he sold $900 worth of strawberries from only a quarter acre of his farm. Like potatoes, strawberries were graded—No. 1s earned almost twice as much as No. 2s at the market. Below, hand-pickers return from the strawberry field in the 1940s.

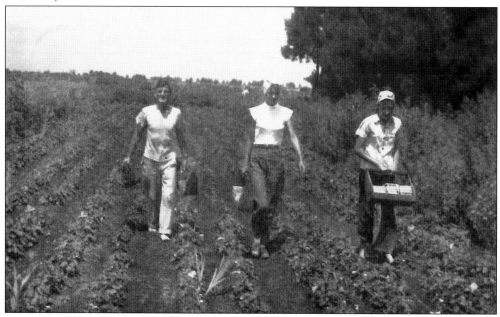

Originally from Italy, Carmino Salvino toured the Davie Experimental Farm in 1914 and purchased 10 acres that same day. By 1916, his wife, Mary, and their 12 children had joined him in Davie—with return tickets in case of bad luck. Salvino introduced Calabrese broccoli to the Florida market and used the warm climate to get ahead of northern markets, transferring seedlings started in Davie to his farm outside of Chicago.

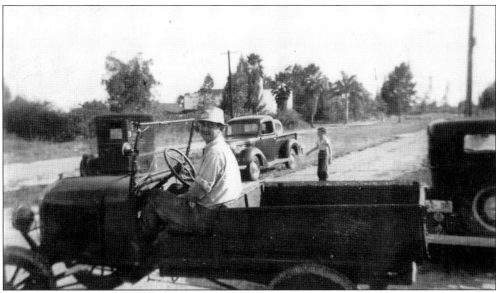

Tony Salvino, who became the eldest Salvino son after his three older siblings died unexpectedly, left school after eighth grade to work on the family farm. He recalled taking vegetables to the Miami market by horse cart on Sunday, selling on Monday, and returning to Davie on Tuesday. In this 1939 photograph, Salvino is driving in his farm truck on a sand road in Davie. He became a Broward County commissioner in 1946 and worked to pave roads throughout Broward.

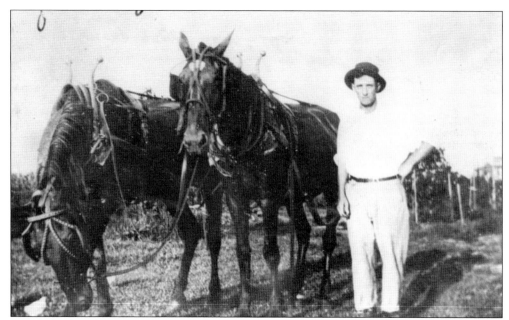

Owen Lloyd used a team of horses to plow his potato field. Horses often wore muck shoes—wide, flat iron shoes—to work in the fields. The muck shoes helped the horses avoid injury from sinking into and getting stuck in the wet soil of the Everglades. Introduced in 1909 by George M. Dykes, the innovative farm tool cost $5 a set.

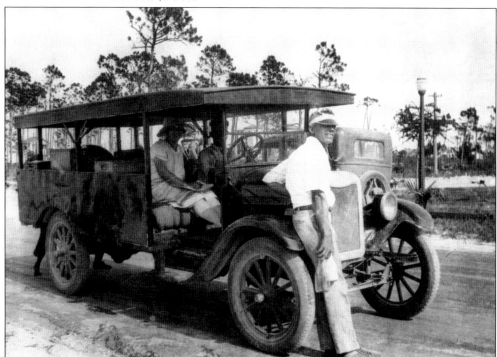

In 1917, Hamilton and Blanche Collins Forman started Forman's Sanitary Dairy, the first dairy in Broward County. In the early years, Blanche cared for the calves, milked the cows, and bottled the milk in the family's own kitchen. The bottled milk was delivered daily by truck.

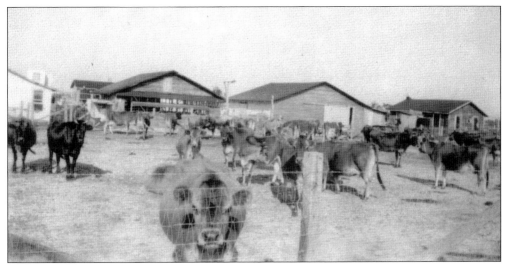

After severe losses following the 1926 hurricane, Hamilton and Blanche Collins Forman rebuilt and had a dairy herd of 55 Jersey cows like the ones pictured here. A want ad in the *Miami Herald* in 1953 sought a "Sober milker" and offered "house, milk furnished. Six-day week, two weeks paid vacation." The dairy remained in operation until construction of the Florida Turnpike cut through the property in 1956.

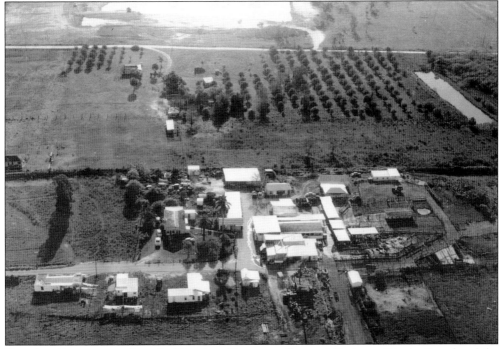

Hamilton Forman served on the Napoleon Bonaparte Broward Drainage District Board and the Everglades Fire Control Board—this helped to navigate an important balance between flooding and drought problems, demonstrating a need for comprehensive water management. The devastating 1947 flood nearly wiped out Forman's Sanitary Dairy in Davie, but with the establishment of what would later become the South Florida Water Management District, development continued in west Broward.

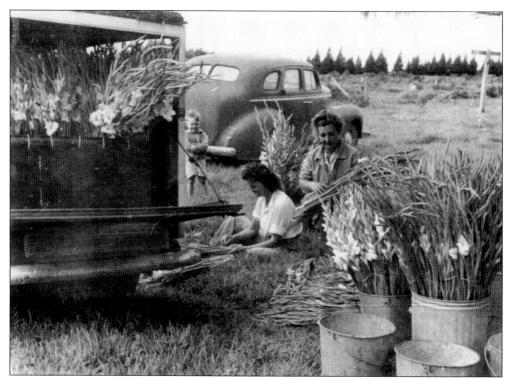

Carrie Williamson and Althea Saar grew flowers such as gladiolas to sell to hotels along Fort Lauderdale and Miami Beach. Any remaining bundles of flowers would be sold from the back of their truck on Andrews Avenue. Roses were another popular flower grown in Davie, and the town held a Rose Festival for four years in the 1930s.

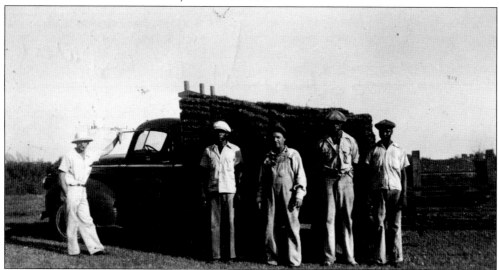

Ralph Hammer (center) started R.R. Hammer Sod, cultivating the first St. Augustine Bitter Blue Sod in Broward County. He and his wife, Anna Elida (the eldest Griffin sibling), raised her six younger brothers after their parents, Anna and Al Griffin, were killed in a car accident in 1937. As the brothers grew, they joined the sod and landscaping business as Griffin Brothers Company, eventually merging their companies with Ralph's.

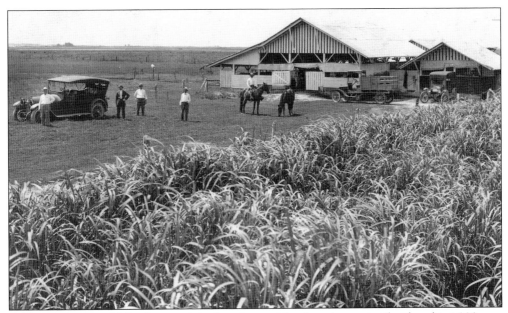

In the 1930s, James H. Bright raised the first thoroughbred racehorses in Florida at his 1,200-acre Davie farm, Martha Bright Ranch. He had a variety of livestock, including hogs, turkeys, and cattle, and experimented with growing feed, like corn and alfalfa. Bright, along with his partner Glenn Curtiss, founded Hialeah and the Hialeah Park Racetrack in 1922. Davie would become known for its equestrian lifestyle.

Cecil Achemire, foreman of the Diamond W Ranch, rides with his whip prepared to control the cattle herds. Cattle drives from the Dania railroad to the open grazing land in the Everglades were common by the 1930s. After the 1947 flood, cattle from the Diamond W Ranch were driven from Flamingo Road east on State Road 84 and north to dry land in Lake Worth, with cowboys on horseback as well as police escorts.

LARGE "SHINE" STILL CAPTURED NEAR DAVIE

Guy and Lee Beam Fined $300 Each But Are Not Jailed; Believed Other Owns Place

(Special to the Metropolis)

FORT LAUDERDALE, Aug. 26.— What is said to be the biggest moonshine still in Broward county was captured Saturday by Sheriff Turner. The still was found on the C. W. Oaks place near Davie, where it is alleged it has been operated by Guy and Lee Beam. The still was complete with a copper boiler having a capacity of 60 gallons or more, a retort, copper pipes, etc. The moonshiners have been making about sixty gallons per day. At the hearing before Judge Shipley on Tuesday morning, the Beam boys were fined $300 each but were not jailed because it is believed they are not the owners of the still.

Not all endeavors in Davie were entirely legal. With Prohibition established by the 18th amendment in 1919, the distant frontier of Davie and the Everglades was ripe for hidden stills and bootleggers. The still featured in this August 1921 *Miami Metropolis* article could make 60 gallons of moonshine per day. Stories of other local bootleggers were passed down through family lore. When Gustava Saar's husband, Augustus, passed away, she reportedly ran a still, selling liquor to make ends meet. Carl Johnson would meet boats that brought liquor from the Bahamas to a mangrove hideaway called "Whiskey Creek"—today's Dr. Von D. Mizell–Eula Johnson State Park. The illegal alcohol was delivered as far as Cleveland, smuggled in a compartment of his touring car. On one delivery, federal agents stopped and searched his vehicle and confiscated his goods but let him go because he had his young daughter with him. She recalled that they missed one case, though, which Johnson sold in order to make enough money to get home to Davie. (Broward County Historical Archives)

Four

EDUCATION ON THE FRONTIER

Families on the frontier took the first steps to establish a school upon arriving in the Everglades. Space for a classroom was limited, and the first students met in a newly constructed packinghouse. When the general store was built in 1911, the new arrivals organized a classroom in the east room of the store with a small group of 10 students and one teacher. The number of students doubled within a year, and the Davie farmers met with the Dade County School Board to request school facilities for the frontier community. The county granted the request for materials, and the patrons of the school—the Davie families themselves—constructed a wooden two-room building.

The school board assigned teachers to the rural school, although housing was an issue in the young community. Early teachers boarded with families or in rooms at the general store or the small hotel. In 1912, Althea Jenne moved from Indiana to Davie with her husband, Ray, to farm. An experienced schoolteacher, she accepted a position as principal of the school upon her arrival.

Within two years, the student population had overwhelmed the small building. The residents petitioned again—this time, to the Broward County School Board—for a new and permanent school building. On May 10, 1918, residents of the small town and their guests gathered for the dedication of the Davie School—the first permanent school building in the Everglades. Charles A. Walsh accepted the building on behalf of the town: "We accept and thank you for this splendid building, a building no matter how large and important this community may grow, will ever be the center of its social action and the main cause of any progress we may make. The citizens of Davie will take pride in it, will maintain it, and cherish it."

The Davie School served the community as a school for over 60 years, providing an educational foundation for generations of students.

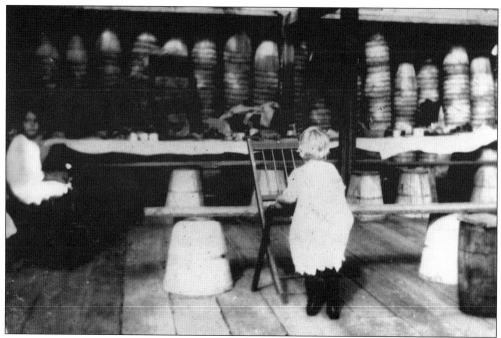

As families began arriving in the area by 1909, school was first held in packinghouses with overturned potato hampers and a plank of wood across them serving as seats. The empty hampers in the back would be filled after a harvest. The first town meetings and church services were also held in the packinghouse.

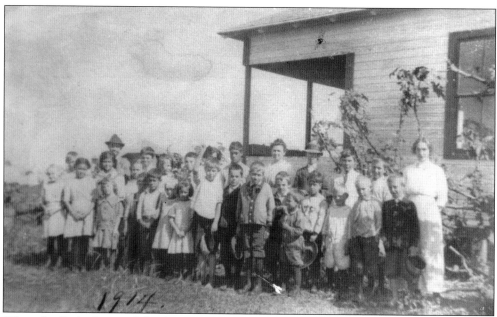

When the Dade County School Board approved funding for a new school in Zona in February 1912, the community built a two-room wooden school west of the general store. The school opened on April 1 and grew to an enrollment of more than 50 students over the next six years.

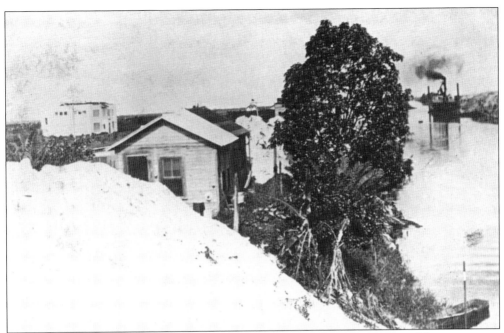

With a growing student body, the town petitioned the Broward County School Board for a permanent building in 1916. The school board approved the petition and acquired five acres of land donated by V.W. Helm of the Everglades Land Sales Company. Designed by Miami architect August Geiger, construction of the Davie School began in 1917. Geiger's plan provided four classrooms on the first floor, a large auditorium on the second floor, a principal's office, and a faculty room. Since electricity was not added until 1923, the tall windows were designed to allow plenty of light into the classrooms. The school (above) stood out on the frontier, facing north on the South New River Canal. The below photograph shows Geiger's Spanish and Mediterranean Revival style with its distinctive keyhole and windows. Ninety students and three teachers attended the first day of school on August 19, 1918.

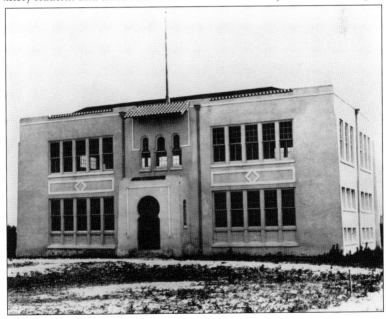

Althea Jenne arrived from Indiana with her husband, Ray, in 1912. They grew a variety of fruits and vegetables, winning first place at the Dade County Fair with their bananas in 1914. She became the first principal of the wooden schoolhouse and worked as a teacher and principal at the Davie School for 34 years. A beloved educator, she retired in 1946 as the longest-serving instructor in Broward County.

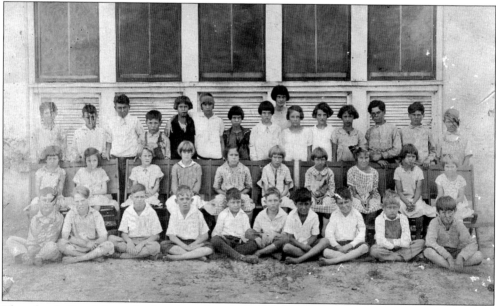

The school offered classes for first through eighth grade, with multiple grades sharing a classroom. The 35 students in the third-through-fifth-grade class are pictured here in 1919. Shoes were not required for school, as demonstrated by the boys in the front row, and light cotton or linen fabrics helped students stay cool in the Florida heat.

A.J. Albertson (left), from Tennessee, was assigned principal of the Davie School in 1921. He is pictured with student Editha Lowe at the west entrance of the school. Due to the lack of housing, he took up residence at the school with his two young children, living in the upstairs auditorium's additional classroom space separated by accordion doors.

Built from poured concrete, the Davie School served as a hurricane shelter for the community. After the devastating 1926 hurricane, the majority of the wooden buildings in Davie were destroyed, but the only major damage to the school was its broken windows. Hurricane shutters were added by 1929. After the storm, many families left Davie instead of rebuilding. Enrollment dropped from 153 students in May 1926 to just over 60, as shown in this 1929 school photograph.

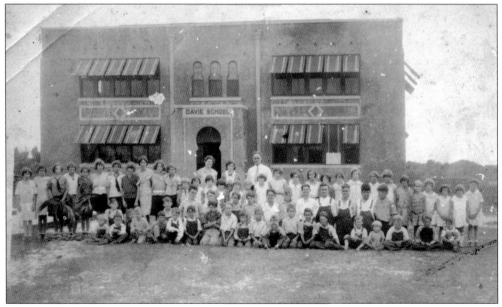

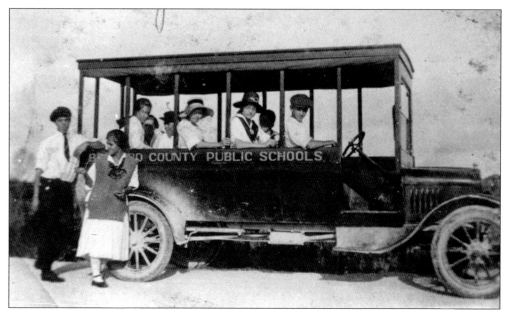

The Davie School only offered classes up to the eighth grade, so to attend high school, students had to travel 24 miles roundtrip to Fort Lauderdale. At first, their options were to walk to the bus in Dania, or catch a ride on a farm truck or boat to Fort Lauderdale; this was a factor in some students ending their education at the eighth grade. When Broward County provided a school bus by 1918, Davie students were able to travel to Fort Lauderdale and return home to work on the farms. One of the oldest students would drive the bus. Norma Hammer Albury wrote in her memoir, *Please Remember Mama*, "If everyone agreed, we would stop on our way home at an orange grove and eat all the oranges we wanted."

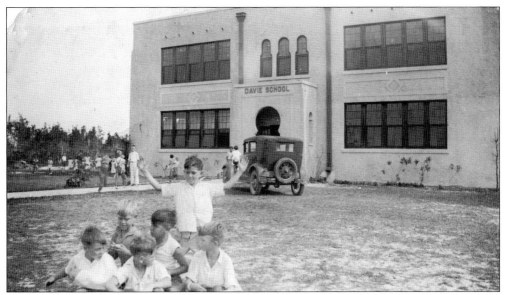

Melaleuca trees were first introduced in the 1910s to absorb water from the wet muckland. The trees behind the school, as shown here in 1936, provided shade and a natural playground for students and were likely planted as a New Deal Civilian Conservation Corps project. If a Florida panther was spotted in the vicinity, students were kept inside until an all-clear was given—a reminder of the lasting wilderness of the Everglades.

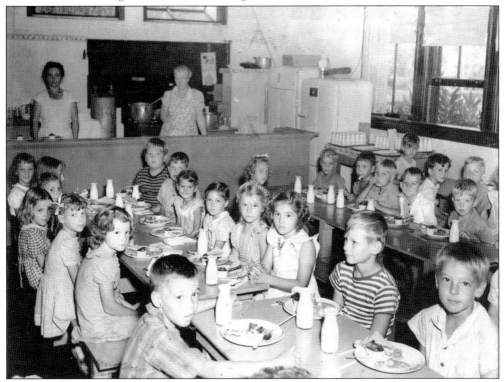

Students brought their lunches to school until the Davie Women's Club began organizing and providing lunch for them as early as 1923, using one of the classrooms as a cafeteria space.

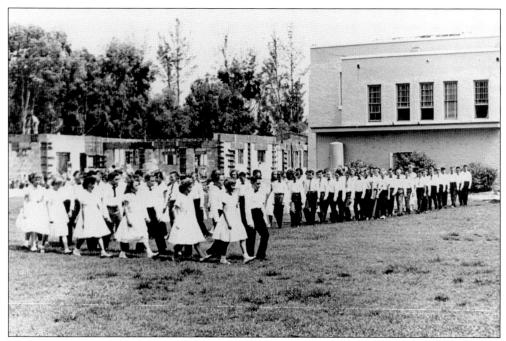

As more students enrolled in the Davie School, called Davie Elementary since the 1930s, additional space was needed. The upstairs auditorium was converted into four more classrooms, and a new building was added to the east that would eventually become the library. A cafetorium built to the west of the original school in 1959 provided a new cafeteria and a stage for school plays and assemblies. The above image shows the cafetorium under construction with graduating students from the sixth grade lined up for their commencement ceremony in the field behind the school. Below, the third-grade classes are performing their play *The Shoemaker and his Elves* on the cafetorium stage.

Until the 1940s, there was no formal school in Davie for Black students; the nearest schools they could attend were in Dania or Hollywood. By 1946, the Davie Negro School was organized in a former building of the naval airfield in Davie with Letitia Hatcher appointed principal. The converted building at the corner of Fifty-Seventh Terrace and Forty-Fourth Street was in the segregated neighborhood in east Davie known as the "Davie Colored Subdivision." This was the last one-room schoolhouse in Broward County when it closed in 1952 with one teacher and 35 students across six grades. Students were then bussed to neighboring schools outside of the Davie district. By 1960, Broward had slowly begun taking steps toward integration, and in the fall of 1965, Black students from the Davie area would be able to attend Davie Elementary and other schools within the Davie district. This photograph shows Potter Park, named after local activist Edna Mae Potter, and the school building that was used as a community space until the 1980s, when it was replaced with a new gymnasium and community building.

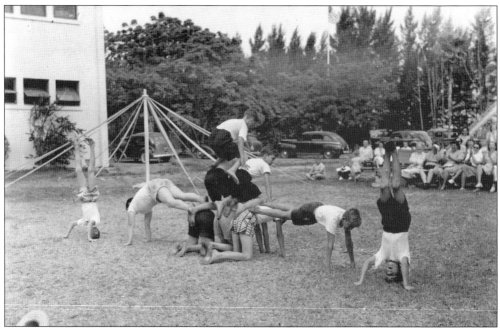

Special events, like the annual May Day festival, brought students and their families together at the school. The May Day pole in the background of the above photograph would be wrapped with ribbons held by dancing students, and performances like acrobatics were given. Two students were selected to serve as May Day King and Queen and were crowned at the event. Enid Hammer Lewis recalled, "We didn't have to wear shoes to school. Some did, but most didn't. When I was in sixth grade in 1946, I was voted May Day Queen. My teacher, Mrs. Woodward, told me I could be queen only if I wore my shoes to school for the rest of the year." The field behind the school would soon be used to house portable classrooms to accommodate the growing number of students.

Pictured here in the 1950s, Griffin Road, once a two-lane thoroughfare, was named for early pioneers Anna and Al Griffin in 1955 at the urging of county commissioner and Davie resident Tony Salvino. In an interview, Anna and Al's eldest daughter, Anna Elida Griffin Hammer, said she learned about the honor the same way everyone else did—in the newspaper. Griffin Road was widened to six lanes in the 1990s.

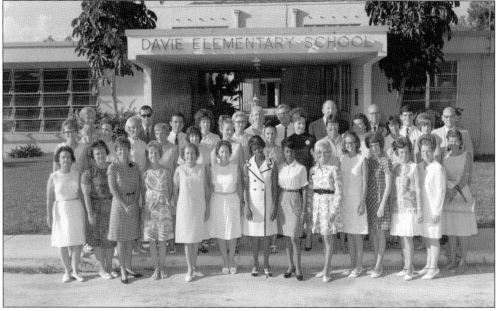

An additional building was constructed north of the school by 1956, blocking the historic façade of the original building from view, pictured here behind the Davie Elementary staff in 1968. Daisy Wright (first row, sixth from right) began teaching at Davie Elementary in 1967, and Annie Gibbons (first row, seventh from left) joined the faculty in 1968 as the first Black teachers for the newly integrated Broward school.

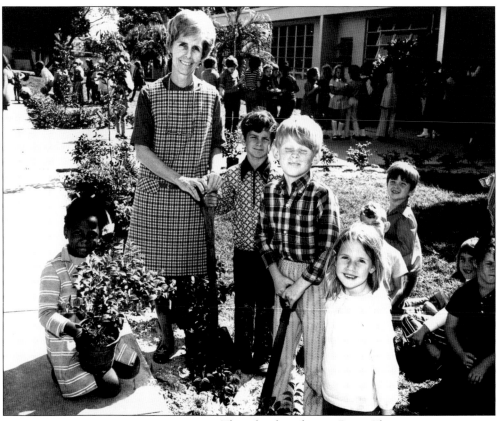

The school gardens at Davie Elementary connected students to the agricultural heritage of the town as it was slowly changing around them, with orange groves being turned into new housing and business developments. First-grade teacher Betty Osterhoudt displays her students' hard work in their garden in the early 1970s.

The population of Davie rocketed from 2,000 residents in 1960 to 20,000 by 1980. Fifteen portable classroom buildings were added to the Davie Elementary campus by the early 1970s to accommodate the overwhelming student population. Ultimately, a new school was built for the community, and students and teachers transferred to the new Davie Elementary campus for the start of the 1978 school year. The old campus was then used as office space for the Broward County School Board.

Five

FOUNDATIONS OF THE TOWN

While families began laying the groundwork for their new lives on the frontier, R.P. Davie's Everglades Land Sales Company continued building canals and draining the land, making more acreage habitable. The land transformed from wetlands to homesteads, and families grew together as a community. By the time the community formally changed its name to Davie in 1914, the foundations for the future town were laid out in its developing infrastructure.

Telephone lines connected the frontier community to the coast, and travel by boat soon gave way to new roads. A barge used to ferry passengers across the South New River Canal was pulled manually by the ferry-tender—a 70-year-old veteran of the Civil War named Sam Rooney. When a bridge replaced the ferry in 1916, Rooney took over as the bridgetender. Compacted rock replaced sand roads, bringing enough motor traffic to require a gas station in the rural community by the mid-1920s.

An early government formed along with the first incorporation of the town in 1925, with Frank Stirling elected as the first mayor at a meeting held in the upstairs auditorium of the Davie School. The lasting effects of the devastating 1926 hurricane led to the dissolution of the town's incorporation within its first year, but the Davie Chamber of Commerce stepped in as a unifying entity for the community.

Families sought religion, with the first church services held in the early packinghouses. Social groups contributed to the progress of the town, like the Davie Women's Club, which organized the first library, and the American Legion, which provided veteran services.

The town incorporated again in 1961 as it faced a changing landscape, with agriculture slowly beginning to yield to development. The growing town was faced with new questions and relied on the early foundations built by its pioneers.

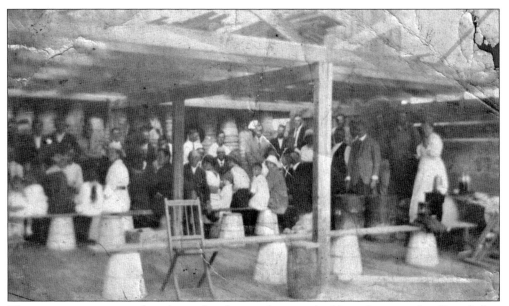

The community convened in the packinghouse, the same building that served as Davie's first school. The two-story structure hosted Saturday night dances illuminated with candles and music provided by residents, including a piano purchased by the Everglade Vegetable Growers Association. Sunday morning church services and association meetings took place in the wooden building throughout the 1910s.

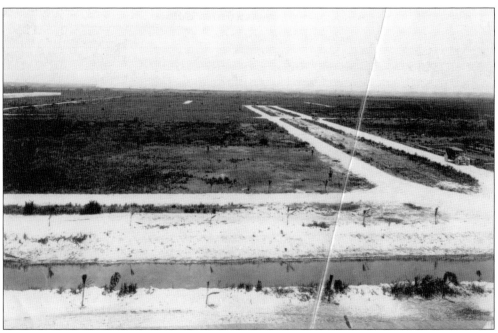

This aerial photograph from 1911 looks south on the corner of Griffin Road and Sixty-Fifth Avenue—construction of the Everglades Land Sales Company hotel is visible to the right. Sand roadbeds line the canal, and newly marked roads lead toward the experimental farm. A rock road connecting Davie to Fort Lauderdale would be constructed by 1916.

TELEPHONE SYSTEM FOR DAVIE FARM COMPLETED AND EXTENSIONS MADE

TELEPHONE BURK DEC 18
SYSTEM HAS BEEN FINISHED
THROUGH THE TRACT AND IS
OF GREAT VALUE—FIRST CAR
SENT OUT

DAVIE, Dec. 18.—The Everglades Telephone company has completed its lines throughout Davie farm and many homes are now connected. This is a substantial, modernly equipped line, with an exchange in the Davie Mercantile company's building, operated by J. James, who constructed the line and who also built the original line into the 'Glades which connected the dredges with the outside world.

Although Davie has long been connected with Ft. Lauderdale and all coast points by phone, Ft. Lauderdale has also desired the new line and offered valuable assistance toward its construction, into that city. The line is therefore being extended to Ft. Lauderdale and has now been completed to within a short distance of that place. It will give greatly added facilities to Davie.

The Davie country club has added a stage to its large hall and the first entertainment to be given on it will be a well-prepared minstrel show. This club seems to have something good always on tap for entertainment and is usually assisted by the very capable Davie orchestra.

The next thing of general interest on its program will be the six o'clock banquet, followed by various forms of amusement and dancing, to be given on the night of Christmas. On Christmas Eve the Davie Sunday school will give an entertainment consisting of recitations, singing and music to which every one is cordially invited.

Basketball

Two basket ball teams have been organized, known as numbers one and two, and both have been getting considerable practice.

Team No. one is composed of Mitchell Leavitt, captain; Jack Barrett, Harry Lowe, Ed Hammer and Dana Crum, with B. L. Palmer as referee, and will shortly play a match with the Ft. Lauderdale team, which recently carried off the honors from Miami. Team No. two is composed of Floyd Nelson, Page Porter, Ed Viele, Paul Hammer and Earl Knouse.

Fifty-three children are now enrolled as pupils in the Davie school.

There is something appealing about the house and home grounds of H. S. Bartell. The house is not expensive,—just an ordinary house, substantially built and raised several feet above the ground. There is no lawn in front,—just some good shade trees and some shrubs. It fronts the main canal, yet the canal itself cannot be seen because of the high bank along its edge. Nevertheless, one possessed of a sense of beauty and coziness will hardly pass the place without several looks at it,—without sensing that there is something innately attractive about it which, somehow, cannot be defined; one is unable to put his finger on just what it is that appeals.

New Houses

The Everglades bungalow of William Lewin has been completed and looks very pretty. Mr. Lewin arranged for the care of his place and left for his previous home in Arizona, stating that he might not return alone.

The new home being built for Mitchell Leavitt, under the direction of A. E. Hurst, is located in the Davie townsite, and will probably be completed within the next two weeks. It is a 5-room bungalow, shingled over the entire exterior, and thoroughly modern.

Mr. Leavitt's mother is visiting him at present, but may return to her home in Chicago within the next few weeks. His father, Professor Frank Leavitt, of Chicago, an educator and lecturer of fame, paid Mitchell a recent visit.

Mr. and Mrs. Rooney, who have long furnished such excellent pies, cakes, bread, etc., have greatly increased their facilities by erecting a special building to be used exclusively as a bakery.

John Aunapu has under construction a large launch for the purpose of handling freight, his present boat being largely inadequate for the purpose on account of the increase in freight traffic. The boat will run between Davie and Ft. Lauderdale.

First Car Out

Davie sent out the first car of winter vegetables shipped from south Florida this season, which, of course, means the state of Florida, since the first shipments come from the south end of the state. This was some time ago, but regular shipments of eggplants, peppers, tomatoes, beans, etc., have been made ever since, and local shipments by auto includes products not included above, such as lettuce, potatoes, chayote, table onions, dasheens, etc. Chayote, known also as vegetable pear, is a product little known in the north, and is cooked like potatoes, squash, and in a variety of other ways, and a delicious salad is made out of it. The vines at Davie bear most of the year, with hundreds of fruits to the vine. The dasheen, little known over the United States at present, is handled in the kitchen like the Irish potato and takes the place of the potato, many persons preferring it to the potato. The United States Government is endeavoring to spread its use and cause its raising over a much larger area, for the value of the tuber is great.

Personal Mention

Rev. E. B. Aycock of Georgia, has occupied his tract adjoining the Davie farm on the west, and fronting the main canal, built a cozy cottage and commenced the preparation of his land. His wife and two young sons came with him.

Miss Minnie Lawrence has left her old home at Calumet, Michigan, and joined her parents, Mr. and Mrs. L. F. Lawrence, at Davie, for permanent residence.

Mrs. Carl Johnson, accompanied by her small daughter, has returned from an extended visit to Sweden and joined her husband at Davie.

A. B. Lowe has returned from a trip of several weeks in the north. During his absence it was rumored that he had arranged to resume the work he had left several years ago in Indiana. "Nothing doing," replied Mr. Lowe, when questioned. "I'm perfectly satisfied with Davie and have no intention of leaving this place."

Dean Cross has rejoined the crew on the Everglades Sugar & Land company's big ditcher, which will resume operations in the Royal Glades in the near future.

Jack Barrett, one of the boys who has worked in various parts of the Everglades so long that it has become home to him, although he has been over much of the world, is out with the engineer corps at present, but drops into Davie at intervals, to "get a square meal," he says.

Everglades Telephone company brought a modern telephone system to the Davie farms. Organized in September 1914, the system carried 25 to 50 subscribers between Fort Lauderdale, Dania, and Davie, and brought easier accessibility and information sharing between the rural community and the coast. Pioneer Tony Salvino recalled in a 1975 interview that C.J. Coyle worked for the telephone company, hanging lines from whatever he could—newly constructed telephone poles or even tree limbs. Newspapers were another means of sharing information—this 1914 article from the *Miami Metropolis* highlights activities in the town like two newly formed basketball teams, individual residents' travel plans, and homes being built. The Davie Country Club organized recreational activities and used the packinghouse for events, which, as shown here, included a minstrel show—these were popular in the 19th and early 20th century and offered a demeaning and false representation of Black culture for white audiences. Information from and about the Black community in Broward County is underrepresented in mainstream newspapers from the time. (Broward County Historical Archives.)

Harry Earle started the Davie Mercantile Company after arriving in the Everglades from the Panama Canal Zone. The company sold farming equipment, fertilizers, and hardware and offered rooms for boarding, leading to it sometimes being called the "Zona Inn." The first telephone exchange was installed at the building in 1914.

By 1913, T.M. Griffin delivered mail by boat—leaving Davie by 8:00 each morning and returning with mail by 1:00 each afternoon. Mailboxes were placed near the general store, which served as the post office, and lined along the road, as shown in this 1922 photograph with Frank Stirling at right. The address for Davie residents was "Rural Road #1, Davie, Fla."

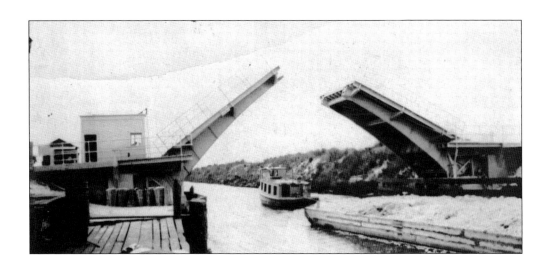

Sam Rooney arrived in Davie in 1912 and ran the first ferry to cross the canal, pulling a barge by a rope from one side of the canal to the other, until a $12,000 bascule bridge, otherwise known as a jackknife bridge, was built over the South New River Canal in 1916. The bridge allowed one-way traffic to cross the canal and opened for boats to travel on the waterway. It was west of the general store dock, which is visible on the left above. The bridge became a popular spot for swimming and jumping into the canal. The below photograph shows the many years of use and the changing landscape around the bridge. Because the wooden planked bridge could only accommodate one vehicle at a time, and with reduced boat traffic on the canal, it was replaced with a new bridge at Davie Road by the 1950s.

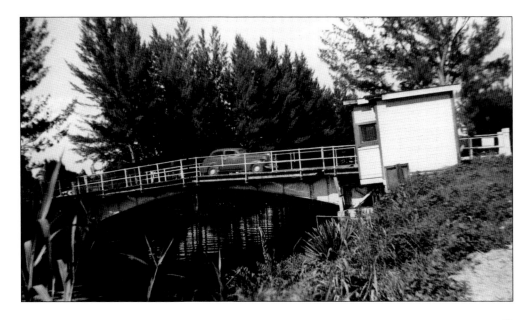

TOWN OF DAVIE INCORPORATED MONDAY NIGHT

Frank Sterling Is Elected Mayor At Enthusiastic Citizens' Meeting

Another organized unit was added to Broward county Monday night with the incorporation of the community of Davie, long known as one of the most productive agricultural sections of Florida, as a full-fleged town. Town officers were elected and all the machinery for self government was arranged for. The name of Davie will be retained, the proposal to change the name being voted down.

Frank Sterling, for 10 years the chief horticultural inspector of the State of Florida, and who has been a resident of Davie since the summer of 1924, was chosen mayor. Five councilmen, a town clerk, and a town marshal were elected also. The town councilmen are: Walter Henry, W. H. Ayers, Will Brumby, Ray Jennie and C. E. Viele. C. L. Walsh is the town clerk and A. C. Brown the town marshal.

Nearly 200 residents of the community were in attendance at the meeting. Of the 70 registered qualified voters attending only two dissented to the plan for incorporation. Later the attending 130 residents of the community who are not yet qualified voters ratified unanimously the action taken by the qualified electors.

Movement to incorporate the community has been under foot for the last few months and was sponsored chiefly by the Davie Growers' association.

Davie has long been outstanding as an agricultural community and its muck land is famed as the most productive soil in the world. Forming there has taken rapid strides within the last year. Approximately 6,500 acres there are planted to citrus groves, several hundred acres are applied to truck farms, and dairying and poultry raising constitute chief occupations. The agricultural census taken last January and February showed the population to be 465 and unofficial estimates place the present population as approximately 600.

The new town is 10 miles southwest of Fort Lauderdale and is connected with it by the navigable New South river canal. Three paved roads also enter the town.

The Everglade Vegetable Growers Association led the movement for incorporation, and in November 1925, almost 200 residents of the community met in the Davie School auditorium to vote. This article from the November 17, 1925, *Fort Lauderdale Daily News* details the meeting. Out of 70 registered voters, only 2 dissented, and the vote for incorporation passed. Frank Stirling (sometimes spelled Sterling) was elected the first mayor; five other councilmen, a town clerk, and a town marshal were also elected. The incorporation provided a means for government and a plan for police and public improvements. When many families lost their homes and livelihoods in Davie after the disastrous 1926 hurricane, the town charter was allowed to lapse; it would not incorporate again for another 36 years. (Broward County Historical Archives.)

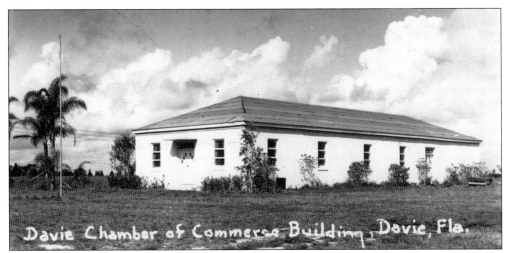

The Davie Chamber of Commerce formed in 1935, electing Frank Stirling as the first president. Early projects outlined by the group included "distribution of literature advertising the city, formation of a baseball team, construction of an athletic field and a playground for children and a campaign to erect new homes." The chamber of commerce planned the first Orange Festival in 1941, and the funds raised went toward erecting the chamber's building.

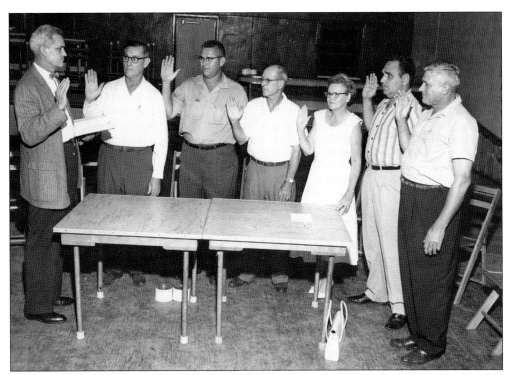

The Davie community voted for incorporation again in June 1960, with the charter passed in 1961. J. Kenneth King (left) was elected the first mayor and is shown swearing in the other town officials (from left to right) L. Winkelhake, R.A. Griffin Sr., Ed Viele, Hazel Shaw (town clerk), Charles Osborne, and Charles Murdock (town marshal). Betty Roberts became the first female mayor of Davie in 1962 and served for 20 years on the town council.

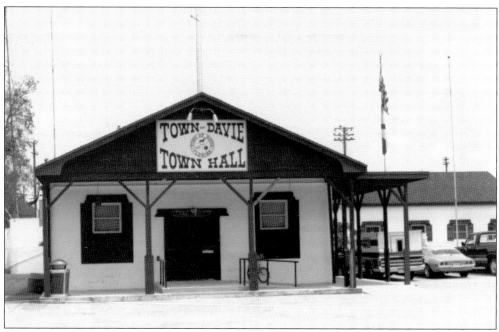

Much like the town, the Davie Chamber of Commerce building transformed through the years. The concrete block building constructed by local men of Davie later served as the town hall, boasting a Western-style exterior by the 1970s. An addition constructed to the rear of the building served as the police station until 1982.

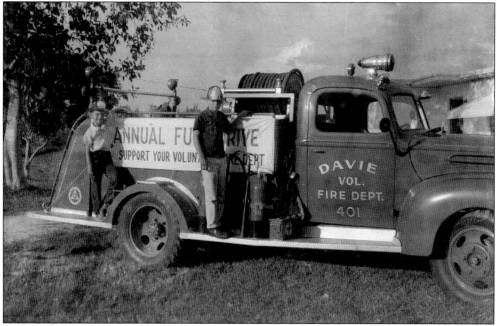

In response to ongoing brush and muck fires in the Everglades, Cecil Achemire, the Everglades fire control warden for Broward County, organized the Davie Volunteer Fire Department in 1952. Achemire was appointed chief, Carroll Anderson was assistant chief, and Billy Rabenau was fire captain.

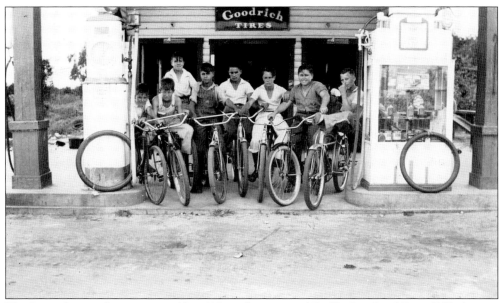

The Davie Service Station opened by 1925 on the corner of Griffin Road and Sixty-Fifth Avenue with a gas station and garage. In 1937, the station was used as a Red Cross emergency first aid station with artificial resuscitation training for children and adults in response to drownings in the canal. Posing on their bicycles in 1939 are, from left to right, Anthony Salvino, Harold Salvino, Howard Griffin, Carl Griffin, Bill Rabenau, Cliff Lloyd, Worrel Minton, and Harry John Griffin.

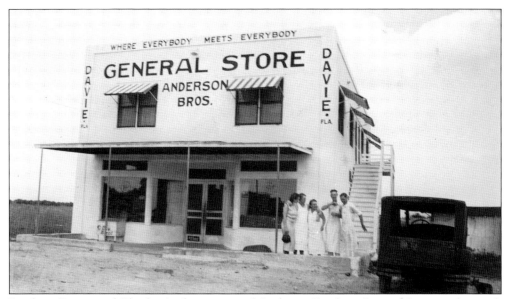

Brothers George and Charles Anderson opened Anderson Brothers General Store on the north side of the South New River Canal in 1935. With groceries and general merchandise, the store's motto became "Where Everybody Meets Everybody." Many Davie Elementary students recall crossing the bridge over the canal between the school and Anderson's to get candy after school.

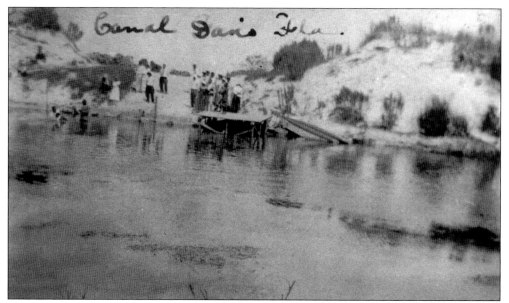

Families brought their religious traditions to the rural frontier community, including those such as this baptism in the canal in the early 1910s. Church services were first held in the packinghouses, and later, two groups organized at the two-room wooden school—the Methodist and Baptist congregations would hold Sunday services in either room simultaneously; some parishioners recalled each attempting to out-sing the other congregation.

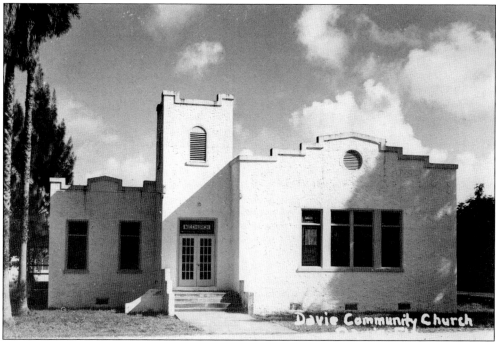

By 1916, the two congregations voted to merge as the Davie Methodist Episcopal Church. The community built a permanent church in 1926 using wood from the old school building along with hired and local volunteer labor. Memorial windows were dedicated to early families such as the Walshes and Vieles, as well as former ministers of the church.

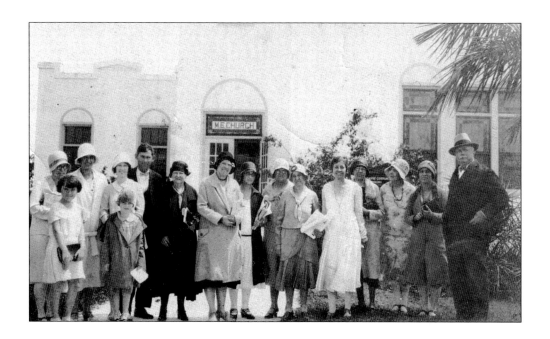

Because it was completed shortly before the 1926 hurricane, the church served as a Red Cross shelter, housing over 100 residents who lost their homes. A larger church was built in 1964 for the Davie Methodist Episcopal Church, known by this time as the Davie United Methodist Church, to accommodate the growing congregation. It was built down the street from the older church on Sixty-Fifth Avenue. The bell from the original bell tower was placed in front of the new church. Today, Our Lady of Victory Catholic Church uses the original 1926 building.

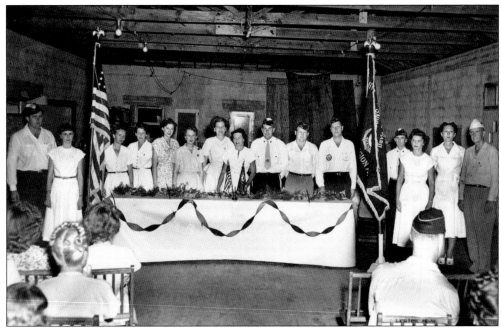

Davie veterans of World Wars I and II formed the Gandy-Wiggins American Legion Post No. 223 in 1946 and the auxiliary membership for their families in 1948. The post was named for two local men who were killed during their service overseas in World War II—Junior C. Gandy and Ira Wiggins. The group organized fundraisers, like an annual Thanksgiving Turkey Shoot, for the benefit of the community. Meetings were held in the Davie Chamber of Commerce building, with officer Joe Wolf (sixth from right) serving as commander, and Cora Link (eighth from right) as president of the auxiliary in 1948. Members of the American Legion and auxiliary held a Memorial Day ceremony on the wooden bridge in 1956, laying a wreath in the C-11 canal.

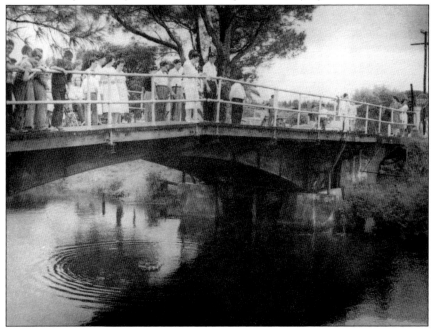

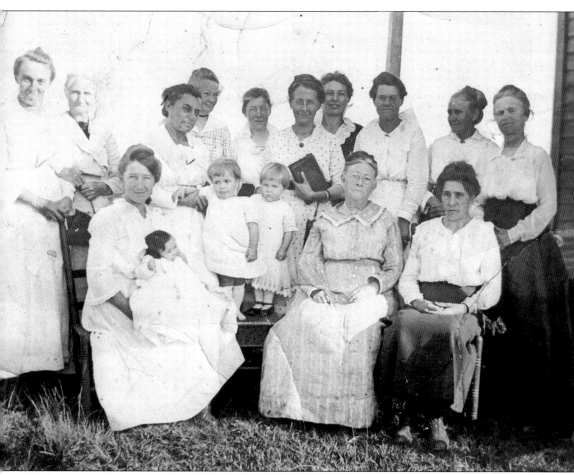

The Davie Ladies' Aid Society formed in the 1910s and was among the first of many women's groups in the frontier community. In 1916, the Davie Suffrage League formed with 15 members in the wooden schoolhouse—including Katherine Walsh as president, Althea Jenne as secretary, and Helen Viele as treasurer. The Women's Christian Temperance Union formed the same year, holding meetings to promote abstinence from alcohol and raise awareness about other local issues. By 1922, the Davie Women's Club had formed. A 1924 *Miami Herald* article described the group: "So many changes are being made in the life of Davie community, new people are moving in, new ideas are being presented and many new things are being undertaken. The Woman's Club of Davie feel their best to assume their share in the opportunities as well as responsibility for the future of the community."

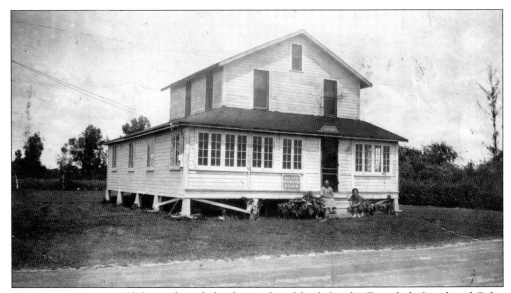

The Davie Women's Club purchased the former hotel built by the Everglade Land and Sales Company, later known as the Lawrence Hotel, for $500 in 1931. The club organized Davie's first library on the second floor of this new clubhouse. When the 1947 flood left many homes inundated with water, families brought their personal books to the second-story library for safety. Although initial construction was delayed by the flood, the group finally broke ground on a new clubhouse on Orange Drive in 1948; the building, where they still hold meetings today, was listed in the National Register of Historic Places in 2016.

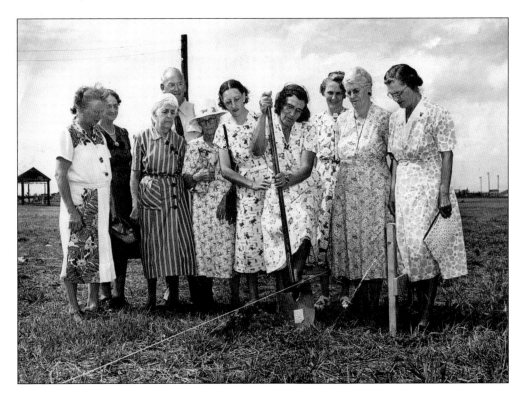

Six

FRANK STIRLING AND THE DAVIE CITRUS INDUSTRY

The Great Freezes of 1894 and 1895 across central and north Florida destroyed citrus crops and whole trees with temperatures as low as 18 degrees in Orlando. Attention turned toward the possibilities farther south on the peninsula and to developing the Everglades. When Henry Flagler's railroad reached Miami by 1896, the labor and equipment required to develop the land became more accessible, and the citrus growers followed the sunshine to the new opportunity.

Frank Stirling arrived in Florida from Ohio in 1907. After studying biology and horticulture in Ohio and California, he spent six years managing the John B. Stetson fruit packinghouse in DeLand. He then served as the chief inspector for the Florida Plant Board, working on eradicating citrus canker. During this time, he visited South Florida and purchased land in Davie. Stirling moved his family to Davie in 1924 and quickly stepped into a leadership role in the community—he was Davie's first mayor (elected in 1925) and a manager and experienced mentor for the area's early citrus groves. An April 1926 *Miami Herald* article said of Stirling, "neither golf nor yachts interest him, but that his real hobby is plants and for the 19 years he has been in Florida he has cherished the ambition to retire to a place of his own and begin practicing his profession in a practical way." He dedicated his life to the growth of the Davie groves and community before passing away in 1949.

With its tropical climate and productive sandy soil, citrus quickly became a blossoming business in Davie. The town has been home to more than 20 groves and packinghouses since 1909. The quality of the citrus grown in the Everglades black muck soil was considered among the best in the state, and at the industry's local peak in the late 1950s, Davie contained over 5,000 acres of bearing groves valued at $5 million. Today, the legacy of citrus in Davie continues through the shared memories of riding on horseback through the groves with the smell of orange blossoms in the air.

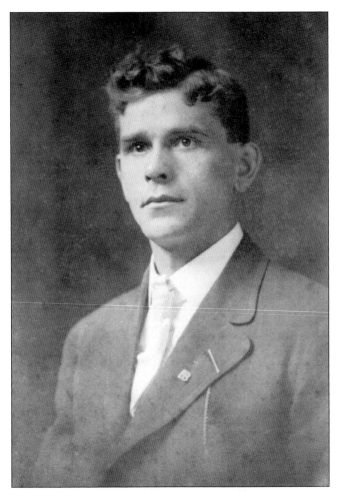

Frank Stirling was born on April 13, 1878, in Gallipolis, Ohio, and studied biology and agronomy. He married Bernice Tedder in 1910, and they had three children. Pictured below are, from left to right, Helen, Bernice, Walter, Frank, and Hully. By 1915, Stirling was advising farmers on eradicating a citrus canker outbreak in Dade County and was made chief inspector for the Florida Plant Board in Gainesville, where he also served as an instructor at the University of Florida, with a particular interest in beekeeping and rose cultivation. He purchased farmland in Davie during this time and moved his family to the community in 1924.

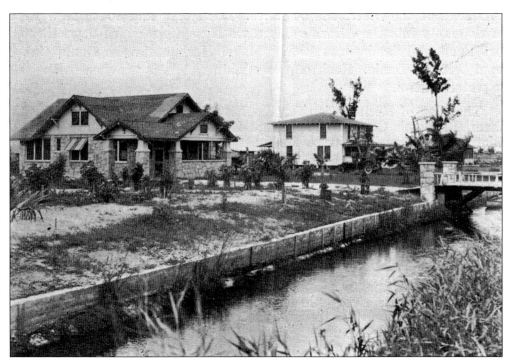

In 1925, Frank Stirling commissioned a home built from coquina rock that was shipped from quarries in Volusia County. His home (at left) remains standing on the west side of today's Davie Road. The sturdy material made the home a secure shelter for the family and many of Stirling's grove workers during the 1926 hurricane. (South Florida Water Management District.)

This caricature from the *Fort Lauderdale Daily News* shows Stirling shortly after he was elected the first mayor of Davie in November 1925. Other leadership positions he held include president of both the Fort Lauderdale Citrus Growers Association and the Davie Growers Association. (Broward County Historical Archives.)

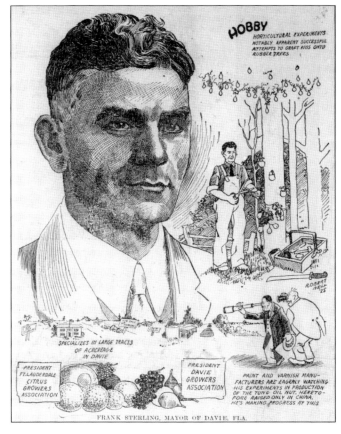

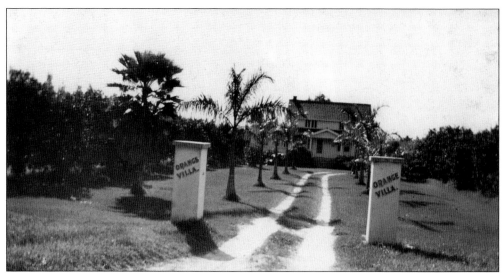

Charles and Katherine Walsh of Ottumwa, Iowa, purchased 40 acres from the Everglades Land Sales Company in 1910. They planted Lue Gim Gong oranges, Duncan grapefruit, and outer rows of Oneco tangerines as a windbreak in 1914 and made a successful first crop in 1918 at $5 per box. They called their home, which was tucked in among the groves, Orange Villa.

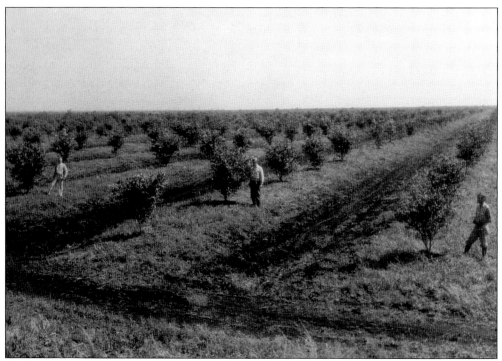

In 1923, Charles Walsh and his partners incorporated Wacico Groves—an abbreviation for Walsh Citrus Company. They purchased 550 additional acres and planted more than 16,000 trees made up of different orange varieties, tangerines, and grapefruits. The success of the Walsh groves reassured other citrus growers of the profitability of the Everglades soil. (State Archives of Florida/Sellard E.J.)

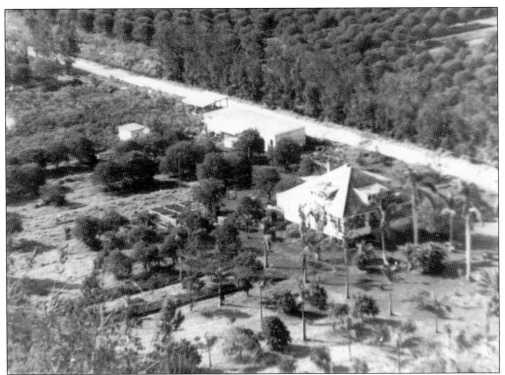

Harry Viele, brother-in-law of Charles Walsh, purchased 30 acres in Florida in 1910 for $60 an acre and planted one of the first citrus groves in the area by 1912. His son Charles "Ed" Viele later managed the groves after returning from service in World War I. Above, the Viele home is seen in its original location off Griffin Road and Seventieth Avenue (also called Viele Road) looking southwest toward their family groves. Citrus was packed for shipping or sold at roadside packinghouses like the one below. Viele Groves remained in the family—and in operation—until the 1990s.

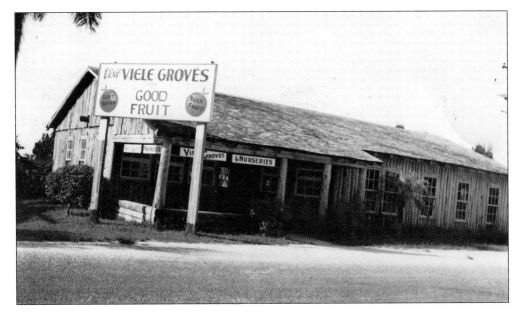

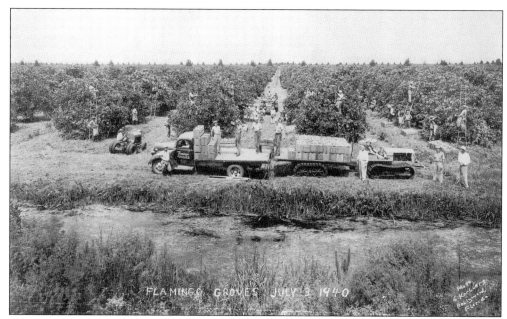

Floyd and Jane Wray purchased land in west Davie, incorporating Flamingo Groves in 1927. Along with 2,000 acres of citrus groves, they cultivated a botanical garden with over 400 species of foreign plants and trees and opened the grounds to the public. Flamingo Road was built by 1928 to accommodate shipping fruit to the coast as well as bringing tourists and prospective investors to the western edge of Davie.

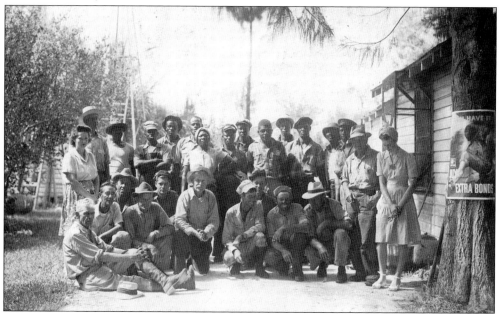

Frank Stirling was a partner in incorporating Flamingo Groves and served as the superintendent, sitting in the first row at far left in this photograph taken with the grove crew in 1943—the image can be dated using the World War II poster on the tree, which was issued for the 4th War Loan bond drive. During the war, labor shortages brought migrant workers to Davie from other areas of the South, like Tennessee and Alabama, as well as from the Bahamas.

Once planted, citrus groves took five years to mature to produce a marketable crop. Oranges were picked by hand and loaded into wooden crates. Lateral canals brought water for irrigation throughout the groves, and workers moved field crates across small bridges with roller conveyor belts onto trucks bound for the packinghouse.

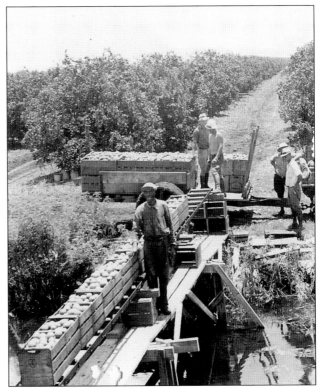

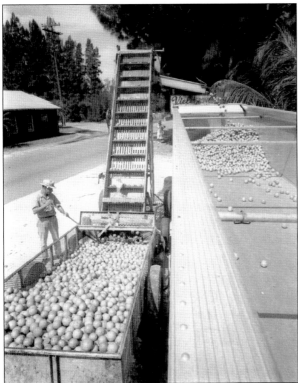

Once harvested, fruit was delivered to a packinghouse, such as the Viele Groves packinghouse pictured here. Specialized machinery moved the fruit on conveyor belts through stages of preparation, which included soaking and rinsing, waxing with a thin layer of paraffin wax for protection during travel, and sorting by diameter and size.

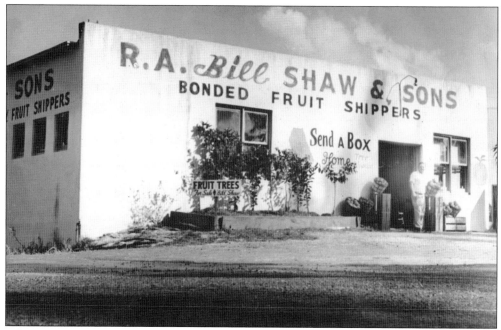

After the fruit was sorted by size, oranges were graded based on appearance, with workers determining whether the fruit would be packed for sale or used for juice. Pictured inside of Shaw's packinghouse below is the sizer where the oranges roll along and fall into bins according to their diameter. After culling damaged fruit and grading, workers carefully packed oranges by hand to ensure the safety of the fruit during shipping.

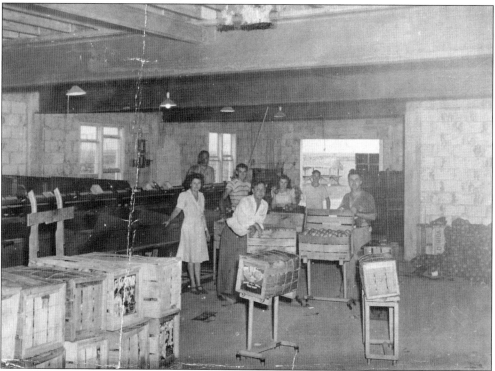

Frank Stirling worked with Morris Cooper (kneeling at left above), advising him on the management of his early citrus groves in Davie in the late 1930s. Cooper's packinghouse, pictured below, stood on Davie Road. When Cooper purchased the Wacico Groves land after the 1947 flood, he set to developing a planned community. In February 1959, Cooper Colony Country Club opened with an 18-hole golf course and swimming pool, and work began on an 8,000-home development called Cooper Colony Estates—the first of its kind in Davie. By June of that same year, Cooper City incorporated independently from the unincorporated Davie area.

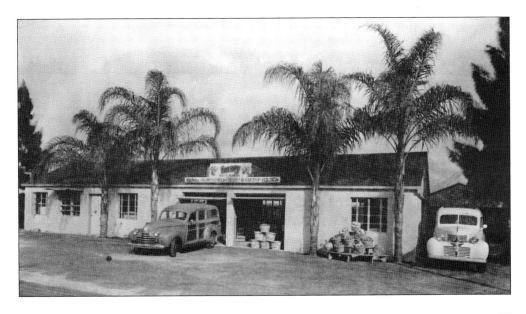

FRANK STIRLING

CANDIDATE FOR

State Representative

Broward County, Group 2

Subject to the Democratic Primary
May 2, 1944

20 Years of Citrus Growing and
General Farming in Broward County

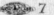 7

Frank Stirling represented Broward County in the Florida House of Representatives from 1945 to 1948. A political advertisement in the *Fort Lauderdale News* in April 1944 stated, "He did not seek the office for which he is a candidate. His many friends, neighbors and acquaintances urged it upon him." Stirling served his term on the agriculture, citrus, drainage, and water conservation committees, among others. He chose not to run for another term so that he could tend to the rehabilitation of the Davie groves after the 1947 flood. At left, Stirling is pictured with his daughter Helen Stirling Gill in their rose garden—his lifelong passion outside of the citrus world. Frank Stirling died on November 12, 1949. Just 10 days later, Broward County commissioners voted to change the name of the Davie-Dania Road to Stirling Road in honor of his lifetime of contributions.

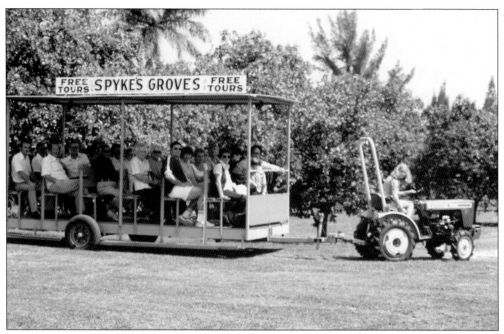

Established in 1950, Spykes Groves took visitors on tours by tram, with guides sharing information about the grove, its history, and the citrus trees. Later attractions, like alligator wrestling and animal exhibits, proved successful. Barbara Spyke remembers, "Tours on the hour, gator wrestling on the half hour. Sometimes it was so busy they ran continuously overlapping to accommodate."

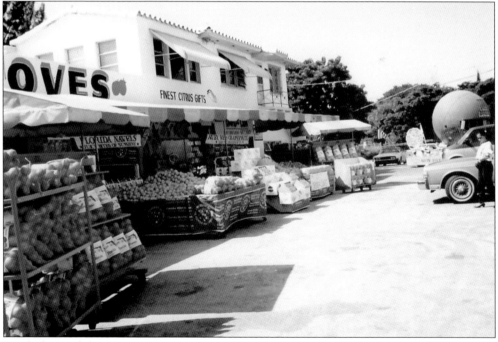

Roadside stands became major attractions selling Davie citrus and other local goods like orange blossom honey, as well as shipping fruit across the country. New River Groves (formerly the Van Kirk groves) opened in 1964 and invited visitors to pick their own oranges from the trees for only $1.

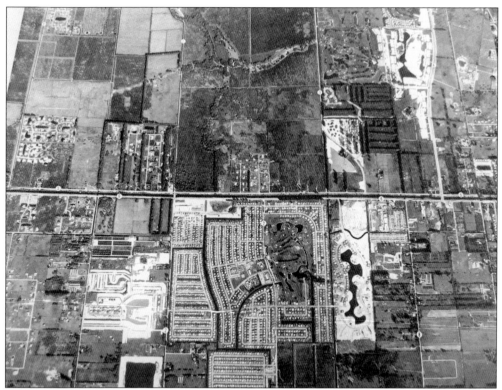

The 1975 aerial photograph above shows the South New River Canal running east-west through the center with groves and natural land still present to the north and Cooper City developing to the south. Citrus groves declined, in part, due to encroaching development and citrus canker scares in Florida during the 1980s, which affected demand. Below, Viele Groves, first planted in 1912, remained in operation until the 1990s—it was among the last groves in Davie.

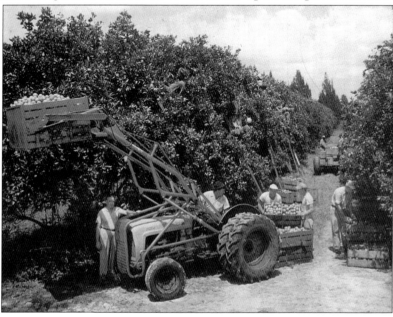

Seven

FUN AND THE ORANGE BLOSSOM FESTIVAL

Aside from the toil and labor on the farms, the people of Davie still made time for fun. Florida was marketed across the United States for its recreational opportunities and endless sunshine—and the early settlers of Davie took advantage of their newly claimed home.

Set miles west from the famed beaches, the canals took the spotlight. The waterway right outside of their homes provided locals with a way to cool off from the Florida heat. Traditions revolved around the canal, included the shivaree, in which newly married couples were met on the evening of their wedding with a crowd at the door making noise banging pans and honking horns—and kidnapping the groom to toss him into the canal. Young athletes trained in the current of the canal; Davie swimmer Alice Shaw won the Fort Lauderdale Marathon, a three-and-a-half-mile swim in the New River, in 1927 and 1928. Jumping from the bridge and the rope swing were rites of passage in the rural community, with all activities undertaken while sharing the waterway with snakes and alligators.

Sports teams competed with neighboring Fort Lauderdale—the Davie team was known as the Sawgrass Savages. Evening dances were held first in packinghouses, then at the school building, and later at the Davie Chamber of Commerce building.

The Orange Festival (now called the Orange Blossom Festival), hosted by the Davie Chamber of Commerce, brought attention to the small town and celebrated the successful orange groves. Held almost every year since 1941, the festival has grown and changed along with the town itself.

While these events brought the community together, many spaces in Davie remained segregated. Places like golf courses and bars refused entry to Black persons or required an alternate entryway. A community Thanksgiving dinner put together a month after the 1947 flood was held at the chamber of commerce building and served over 300 pounds of turkey—but according to a *Fort Lauderdale Daily News* article that November, Black residents "received the full dinner, served in their section of the town." Although Davie was the shared home of residents regardless of their race, community experiences would not be integrated until later.

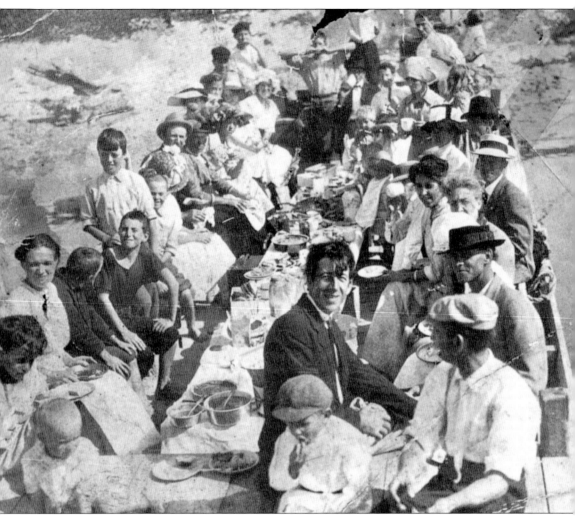

The Concordia Club (later the Davie Country Club) organized activities like this trip to the beach by barge. Capt. John Aunapu operated one of the first boat lines between Lake Okeechobee and Fort Lauderdale and volunteered to pull the barge, with families aboard, to the beach in Dania for Thanksgiving Day in 1913. The club organized picnics, sporting events, dinners, and dances for the community. Guests were invited from Fort Lauderdale, with special boats running from the coast to accommodate crowds. Dances were held on the second floor of the Everglades Vegetable Growers Association packinghouse, and a piano was installed by the club in 1914. At a Christmas celebration organized by the club in the wooden schoolhouse, music was performed by the community, along with "selections on the Victrola," followed by dancing. The Davie Country Club held events until the 1950s.

This photograph of boys swimming in the canal in 1916 shows the size of the canals and the height of the bank. The dredges dumped excavated soil alongside the canal, creating banks as high as 20 feet. A ladder is visible on the left making a steep descent into the brown water—it was clean, but brown from thousands of years of decomposing plant life and tannins in the soil.

Norma Hammer Albury recalled, "I guess most of us learned to swim by the trial-and-error method. In those days you went in the water and fooled around and floundered until you learned to paddle enough to stay afloat. . . . I think a great deal is denied a child in this day of instructors-for-everything, when he is not allowed to discover, suddenly all by himself, that he has taught himself to do something important and vital."

Rope swings at popular swimming spots on both the North and South New River Canals were for those with an adventurous spirit. As for alligators, they shared the waterways—someone (usually) kept watch from the bank to alert swimmers. (Thomas Booth.)

The canal set the backdrop for the unique lifestyle of families in the growing community of Davie, as demonstrated by this family enjoying a picnic at their homestead beside the North New River Canal in 1959. The site of this property was nearly overtaken by the building of Interstate 595. (Thomas Booth.)

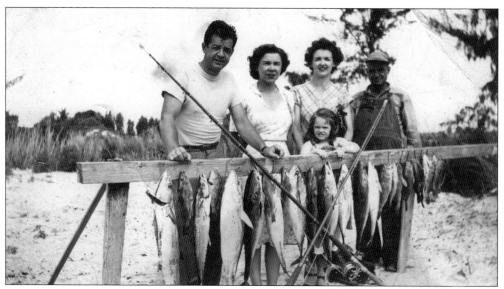

Fishing for varieties of bass, catfish, tarpon, snook, and more in the canals provided an accessible dinner as well as sport. Ed Hammer (far right) stands with a family displaying their catch next to the canal in the late 1940s.

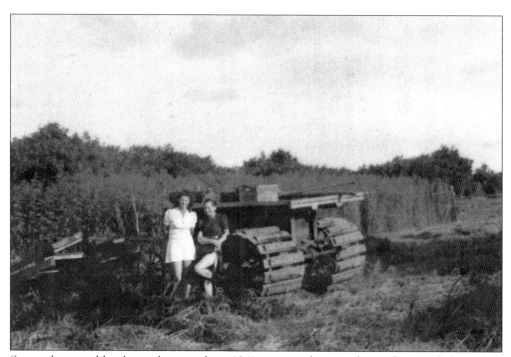

Swamp buggies, like this early example in 1941, were used to travel into the Everglades to fish, hunt, and camp. With large wheels and raised seating, the vehicles could navigate the shallow waters and rugged terrain.

The first game of baseball in the Everglades was played on May 8, 1913, at a picnic celebrating the one-year anniversary of the Zona community and hosted by the Concordia Club, as reported in the *Fort Lauderdale Sentinel*. The *Miami Metropolis* reported that guests arrived by boat on the canal from Fort Lauderdale and Dania, with boats "tied so thickly along the canal that it was almost impossible to get through . . . Fort Lauderdale and Dania turned out en masse, and only those who were either too old or too ill stayed at home." More than 500 people joined the celebration. (Left, Broward County Historical Archives.)

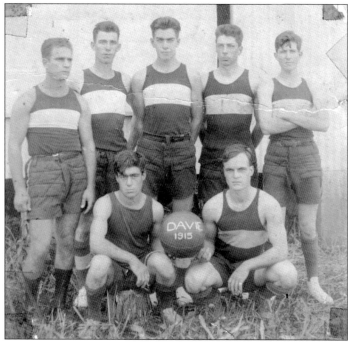

The Davie basketball team first organized in 1915 with a court described in the *Miami Herald* as smaller than regulation size and "enclosed in a cage, so that there are no out of bounds rules." Teams from Miami and Fort Lauderdale, along with Davie, would travel between the cities for games. After a game in Davie against the Miami team, the players stayed for dancing at the community packinghouse, and dinner of ice cream and the newly popular treat, hot dogs. Basketball was popular across all ages, and the Davie School had both boys' and girls' basketball teams by 1928.

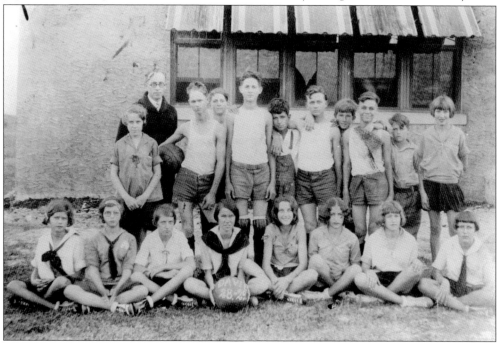

Organized in 1921 and led by scoutmaster George Orcutt of Troop 1, the Davie Boy Scout Band performed at events in Davie, Fort Lauderdale, and Miami—from left to right are (first row) Burton Sewell, Fred Millard, Fred Aunapu, Harold Saar, T.A. Griffin, Bill Griffin, C. Lowe, Harry Earle, and L. Lowe; (second row) Foster Ingalls, Clarence Henry, John Cantwell, Harold Hill, George Orcutt, Dan Knouse, and Dee Millard.

Dances sponsored by the Davie Country Club were held biweekly in the auditorium of the Davie School. Music was provided by local musicians, with occasional performances by groups like the Johnson-Brinson Orchestra. This 1940 photograph shows the auditorium with the original accordion doors across the west side of the room before the space was used for four additional classrooms.

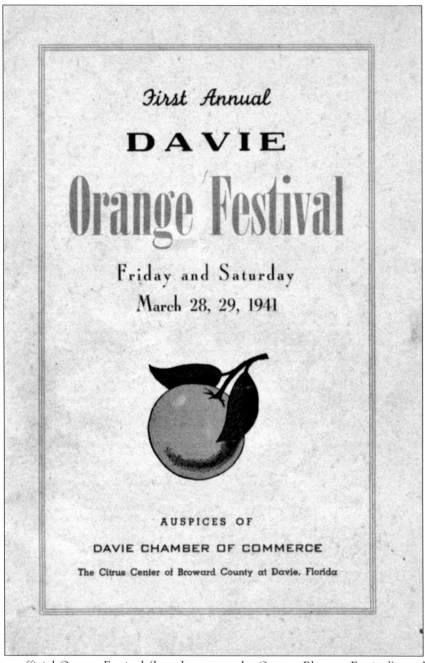

First Annual

DAVIE

Orange Festival

Friday and Saturday
March 28, 29, 1941

AUSPICES OF

DAVIE CHAMBER OF COMMERCE

The Citrus Center of Broward County at Davie, Florida

The first official Orange Festival (later known as the Orange Blossom Festival) was held in 1941. The event was sponsored by the Davie Chamber of Commerce and intended to "advertise the resources and products of the Davie section, but in addition, with its surplus funds to create a Park and Community center for the residents of Davie," as stated in this pamphlet. Citrus, vegetable, and flower exhibits showcased local farms and groves. Activities during the two-day festival included tractor races, greased pig contests, wife and husband calling contests, carnival rides, and the first formal rodeo events in Davie. The 1941 event raised funds to construct the chamber of commerce building.

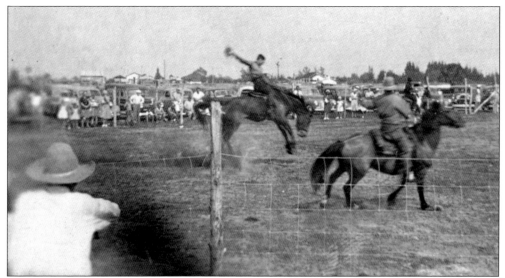

As part of the 1941 festival, the rodeo featured all-Davie talents demonstrating their skills in roping, riding, and bulldogging. The rodeo grounds consisted only of the fenced arena shown here. The successful event was the first of an ongoing season of rodeos populated by local men, women, and children, with prizes awarded for horsemanship, marksmanship, and trick riding.

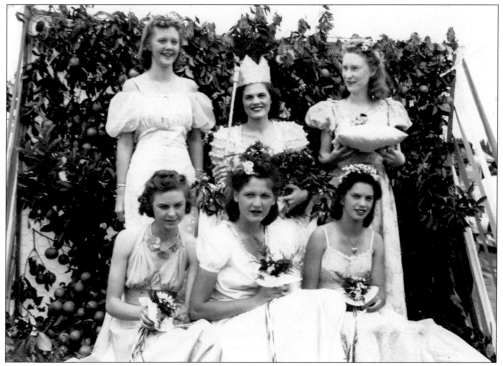

Frances Munson was elected the first Orange Blossom Queen in 1941 and crowned on the first afternoon of the festival with a silver crown and golden scepter on a throne decorated with oranges and orange blossoms. She is pictured along with her court, from left to right: (first row) Helen Stirling, Marie Salvino, and Lyda Mae Aunapu; (second row) Mary Elizabeth Troy, Munson, and Mary C. Anderson.

The Spirit of Davie — and of America

By HARRY EARLE

•

The opening of the Second Annual Davie Orange Festival finds our Nation, the United States of America, involved in a total war, a war we must win for the sake of Liberty and Humanity throughout the entire world.

We have already obtained a glimpse, and only a glimpse, of the sacrifices each one of us will be called upon to make. In all probability one year from this day, our present daily mode of life may be only a pleasant memory to comfort us amid sorrow, grueling work, and perilous times. We are sure of one thing, however, we shall all carry a smile on our lips, along with a steeled determination, in our hearts, to wipe off, completely and irrevocably, from the face of the world those barbaric forces which today stand gloatingly on the sacred threshold of our ramparts.

This Festival stands as a symbol of what community spirit, team work, and the "will to do" can accomplish. This spirit developed to the full in each hamlet, village, town, and city of our fair land, will make the national spirit, the national unity, and the national will, so vital for victory over our enemies. Let Davie, then, set the example for our neighboring cities, to the State of Florida, indeed, to the entire Nation, of what unity and the "will to do" can accomplish.

Davie, today, is the agricultural and horticultural center of Broward County, with a payroll of $300,000 annually, but yesterday, where Davie is located, there was nothing but Everglades swamp land. Fighting, fighting continually, against flood, frost and storm, through gloomy disappointments and sunless days, the Davie of today stands as a tribute to hard work and perserverance, a tribute to men and women who "loved" the land and "stayed with it."

Our nation, the United States of America, stands today as a great symbol in the world of those same qualities that made Davie what she is today.

So, let us, though overhead the low, threatening, black storm clouds are approaching, with a simple trust in God, calmly, but with determination, see the danger through in the true spirit of Americanism — the spirit of '76 — the Spirit of Davie — the Spirit of America.

•

The Davie Chamber of Commerce

By HARRY EARLE, Secretary

The attack on Pearl Harbor in December 1941 shook the country as men and women enlisted and wartime production shifted to supply the troops. In Davie, the second annual Orange Festival went ahead as planned, with special commemoration given to the war effort. Secretary Harry A. Earle of the Davie Chamber of Commerce wrote this address titled "The Spirit of Davie—and of America," and included it in the festival pamphlet. The *Hollywood Herald* described Davie as "using all resources at her command to aid in defeat of the Axis. And tomorrow, when peace returns, her fame will spread still more as one of the world's richest areas for summer oranges and winter vegetables—and an ideal community to live, work and play." The festival took a three-year hiatus during World War II.

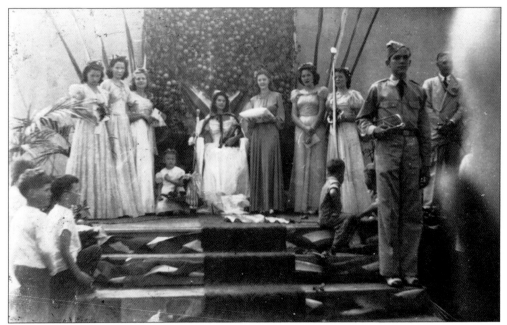

Lyda Mae Aunapu was elected the second Orange Blossom Queen in 1942 with a "penny election." Candidates raised pennies, at a penny per vote—whoever raised the most was crowned queen. Howard Winton is pictured holding the trumpet at the crowning. From left to right are Mary Pride, Hilda Franklin, Bernadine Wabnitz, Aunapu, Mary Elizabeth Troy, Marie Salvino, and Doris Taylor.

After World War II ended in 1945, the people of Davie revived the Orange Festival in the spring of 1946. An estimated 10,000 people attended the returning festival. By 1947, the Gandy-Wiggins American Legion Post 223 made plans—with donations from the community—to build permanent rodeo seating, which is shown in the background beyond the massive field of parking.

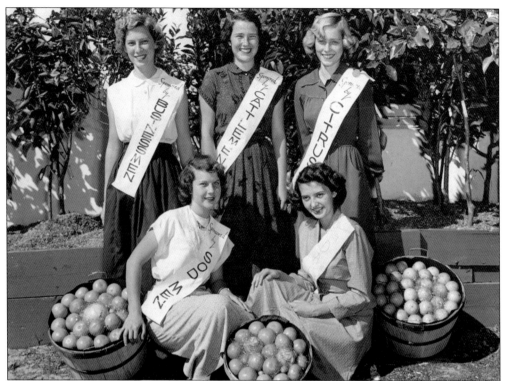

In 1951, Orange Blossom Queens were sponsored by different industries in Davie. The contestants pictured here are, from left to right: (first row) JoAnn Gandy (sponsored by sod men) and June Beasley (dairy); (second row) Esther Winkelhake (businessmen), Mary Winton (cattlemen), and Maxine Cole (citrus). Winton took the crown with the most popular votes.

The election of the Orange Blossom Queen changed through the years, and by 1958 it had become a pageant-style event, with contestants judged on personality, charm, figure, and talent. From left to right are Alice Hart, Sandra Ousley, Frances Biggs, Linda Douglas, Jean Murdock, Aleta Fay Durden, Sharron Osterhoudt, Martha Coulter, Marty Stampfli, and Judy Harness. Osterhoudt was crowned queen at the Coronation Ball at the chamber of commerce building before the six-day festival.

The barbecue remained a popular staple of the Orange Festival from the beginning. Volunteers from the Davie Chamber of Commerce cooked hundreds of pounds of ribs over open barbeque pits, charging 50¢ for a dinner that included fresh corn dodger rolls, cold slaw, and coffee. Here, Ralph and Ed Hammer man the barbecue, with piles of wood for the fire in the background.

The festival brought the community and guests from around the state together in the blooming town of Davie. The tradition of the Orange Blossom Festival has continued and grown since 1941. As a much-anticipated annual event, it remains as a tether to the agricultural heritage of the town.

Eight

THE DAVIE RODEO AND GOING WESTERN

Following the success of the 1941 Orange Festival Rodeo, the Davie Chamber of Commerce sponsored more rodeo events. The rodeo committee organized a two-day event produced by local rancher and Broward County deputy sheriff Claude Tindall in July 1946 that drew more than 7,000 people to the fairgrounds, with thousands more turned away. The *Miami Daily News* reported, "Officials finally gave up trying to pack any more in the grounds and for an hour and a half after the rodeo started automobiles were turned back at the rate of 13 a minute."

By 1947, bleachers that could seat 5,000 had been constructed, and more were built with over $9,000 contributed by Davie residents. Local talent soon faced national competitors as the event attracted cowboys from around the country, with each event earning them points toward the title of World Champion Cowboy. The rodeo grew in recognition and brought attention to the growing cattle industry in Davie. Rodeos held each fall and spring, and later more frequently, were sponsored by a variety of organizations such as the Davie-Broward Horsemen's Association and Davie for Horses.

The cowboy aesthetic on the wild western edge of Broward County began to influence the town, opening up surprising new industries. Pioneer City, an Old West theme park, opened in 1966 with stagecoaches and gunslingers reenacting John Wayne–style shootouts. Movie director Luke Moberly established his studio in Davie and enticed the Davie Chamber of Commerce to "Go Western" with false storefronts on downtown businesses to strike up tourism—and to use as his film set.

Dr. Glenn Sutliff, president of the Davie Chamber of Commerce in 1965, responded to this proposition: "I can't understand why the people would want a town to be western when it hasn't any connection with the west. If we were any further east, we would be in the ocean."

But the idea smoldered in the town. By 1980, an ordinance had been passed to create a "western-themed" downtown to reignite the dwindling business area on Davie Road. The question for businesses then, and one that has continued to saddle the town, is: what is "western"?

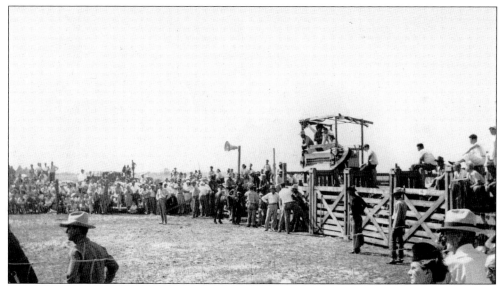

Local volunteers constructed the Davie Rodeo in the early 1940s. Wooden fencing and barbed wire enclosed the arena along with the judges' stand and chutes. There was no formal seating, and spectators watched from the sidelines—or the tops of their cars—to get a better view.

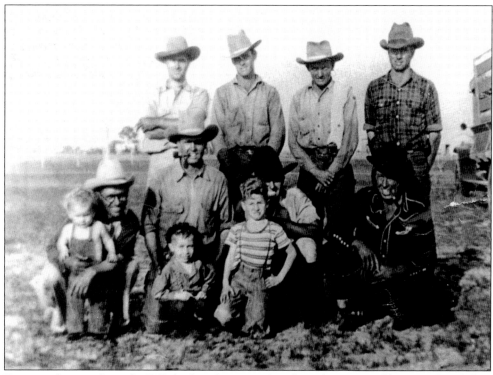

Davie cowboys in the early 1940s built and competed in the rodeo. Pictured here are, from left to right, (first row) Billy Keene and son, Murray Bryan with Charles Lloyd, Charles Trice with Quinn Tindall, and Raymond Henderson; (second row) E.C. Collier, Lurcey Bryan, Cecil Achemire, and Claude Tindall.

The community expected 40,000 visitors for the 1947 Orange Festival, hastening the construction of permanent bleachers for the rodeo. Workmen and volunteers, including the contestants for the Orange Blossom Queen crown, built the concrete foundation and wooden seating. From left to right are Patsy James, Irene Salvino, Mary Winton, Ruth Bateman, and Patsy Hinson.

The 1947 Orange Festival and rodeo was a success and brought 50,000 visitors to Davie. The three-hour rodeo featured rodeo stars from around the state, nation, and continent. The rodeo went on to feature events for men, women, and children, including trick riding, bull riding, and whip acts.

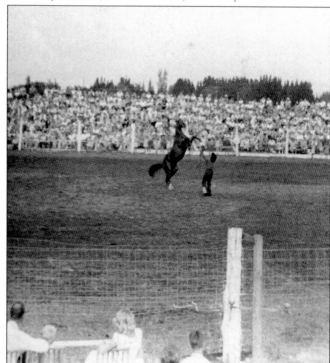

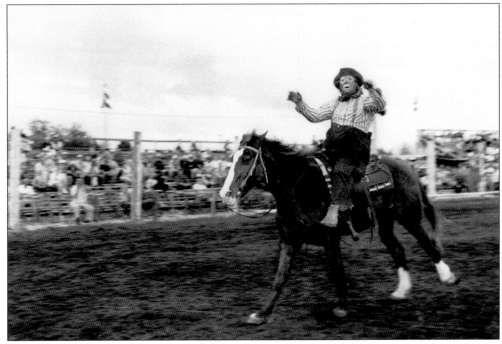

Bull riding and bucking broncos were a highlight of the rodeo, and the rodeo clown played a valuable role in distracting the dangerous animal from a fallen rider as well as entertaining the crowd. This clown in the 1948 rodeo rides without hands as part of his trick skills.

The rodeo was an exciting activity for the community and Davie children. Caught sneaking into the rodeo grounds in 1946 are, from left to right, Alice Scott (on bicycle), Elsie Scott, Noreen Mains and Enid Hammer.

Along with crowning Betty Ann Loper the Orange Blossom Queen in 1946, Margaret Kirkland was crowned the first Rodeo Queen—"one of the outstanding girl riders of the Davie cattle ranges." Selected to reign over the July rodeo weekend, Kirkland opened each day with a grand entry on horseback at the Davie arena.

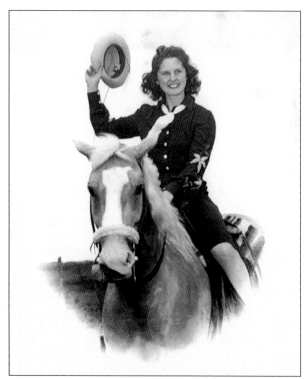

The community quickly addressed issues as they arose, like eliminating dust with a special mixture of dirt and clay. The surrounding grounds were fogged with the now-banned insecticide DDT to reduce mosquitoes and flies. Numbered tickets were issued for assigned seats, as shown here with numbers painted on the wooden bleachers, guaranteeing all guests a clear and unobstructed view of the event.

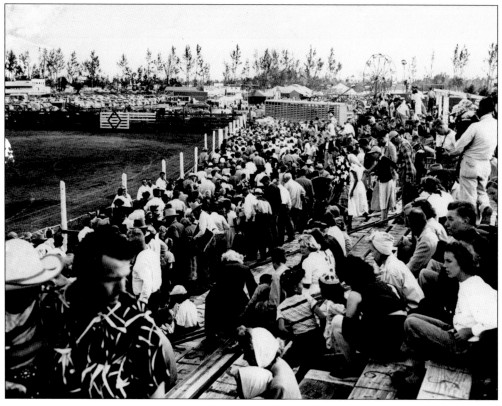

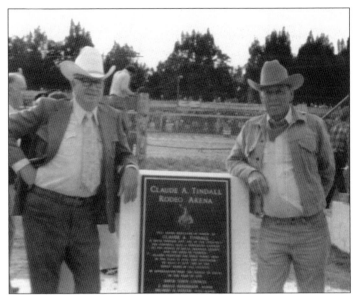

As the rodeo manager, Claude Tindall (left) traveled the country recruiting rodeo stars while also serving as deputy sheriff for Broward County. In appreciation of his efforts in founding and advancing the Davie Rodeo, the grounds and arena were dedicated to Tindall in 1977; he is pictured here with mayor Merle Henderson.

In 1957, Dick Griffin invited his Miami business partner "Dub" Weekley and his family to the Davie Rodeo. Seven-year-old twin brothers Troy and Dan Weekley told their father then that they wanted to be cowboys. Since 1986, the brothers have produced the performances at the Davie Rodeo Arena—first as the Five Star Rodeo and now as the Weekley Brothers Davie Pro Rodeo. Posing in 1987 are, from left to right, Leroy Mason, Troy and Dan Weekley, Mayor Bud Jenkins, Donald Parrish, and Wayne Weekley.

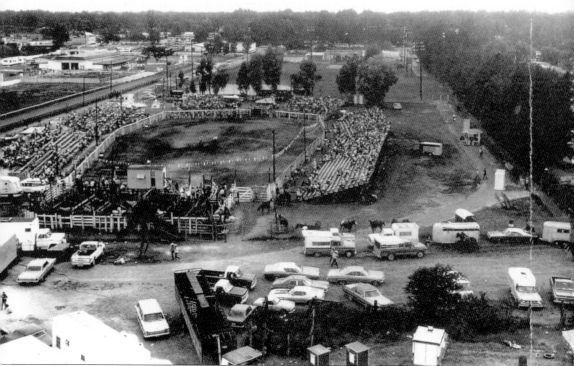

The rodeo arena and grounds suffered from the effects of time and faced threats of being condemned throughout the 1970s. Each time, volunteers stepped up to rally for repairs. The town purchased the site from the chamber of commerce in 1972, but by 1978, the town council considered relocating the rodeo so that the area could be used for baseball fields. Members of the community feared that if the arena was torn down, a new one would never be built. Around 200 cowboys and horse enthusiasts attended a town meeting in 1979 to encourage preservation rather than demolition. The town agreed. Over the next five years, with contributions from the newly merged Davie–Cooper City Chamber of Commerce, the volunteer group Davie for Horses, and a loan to be repaid with revenue from events held at the rodeo, the rodeo received a $600,000 renovation that included updated seating, a new concession stand, new electrical systems and lighting, and an aluminum roof that allowed for events to be held in any type of weather. The last "rodeo under the stars," like this one, was held in 1985.

In 1966, Myron M. Weiss Sr. financed an "Old West" theme park called Pioneer City with a replica Western town that included a saloon, hotel, bank, stable, blacksmith shop, assay office, Wells Fargo office (including the Wells Fargo stagecoach pulled by horses, as pictured above), jail, town hall, an Indian village and trading post, and more. Can-can dancers performed onstage, and a sheriff and outlaw gunslingers had shootouts in the streets multiple times each day. Two paddlewheel boats brought guests into the park from the parking lot, and a replica 19th-century steam engine named *Jenny Lynn* (pictured below) traveled on its own narrow-gauge railroad tracks. Two lone buffalo are watching over their new frontier in west Davie in the background. The park closed in 1968, and the site later became the home of the popular Kapok Tree restaurant. It is the current location of Long Key Natural Area and Nature Center. (Both, State Archives of Florida/Barron.)

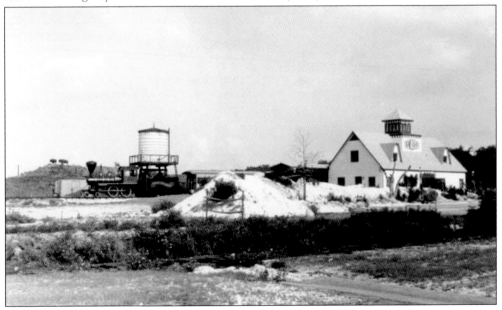

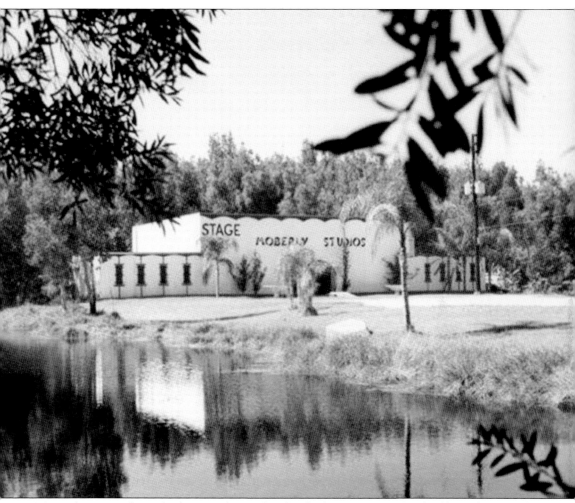

Movie director Luke Moberly wanted to make Florida the new center for the film industry and built his studio in east Davie in 1964. Moberly created sets in anticipation of popular film genres, including a 1911 replica of downtown Fort Lauderdale. He invited the public to visit his studios, operating a restaurant and offering tours of the sets when they were not being used for productions. By 1972, Moberly had shot 26 feature films at his Davie studios, including scenes for his most well-known movie from 1969, *Little Laura and Big John*— a fictionalized Bonnie-and-Clyde-style retelling of the 1920s Florida bank robbers the Ashley Gang. Although Moberly's suggestion of building Western-themed dummy fronts on downtown buildings may not have been fully accepted at the time, the idea lingered in the community. (Moberly family.)

In 1960, Davie's population of 2,000 was miniscule compared to that of nearby Fort Lauderdale, which registered 83,648 the same year. However, Davie boomed to 20,000 residents by 1980—and the rural nature that made the town attractive was threatened by development. Ensuring the community remained horse-friendly required planning to maintain low density and measured growth. The rural lifestyle of Davie and the Wild West aesthetic of the rodeo overflowed into the town. Themed events like the "Shades of the Wild West" for the 1960 Orange Festival parade introduced the imagery of covered wagons and saloons that was popular in Hollywood movies at the time. When town hall took over use of the chamber of commerce building, a westernized wooden exterior was added by 1969. By 1980, a law "requiring a western motif" for downtown buildings was initiated to revive the downtown area, encouraging businesses to adapt storefronts with a Western look that one chairman described as "the general concept of Western architecture presented to us through the film industry." While the spirit of the concept remains, the community continues to define for itself what Davie will be in the future. (State Archives of Florida.)

Nine

HARD TIMES

The community spirit of Davie shined through the hardships of the 20th century. World War I and the 1918 influenza pandemic changed the world and did not miss the small town on the edge of the Everglades. The Davie School, built while the United States engaged in the war overseas, closed along with public schools across Broward County for two weeks to prevent the spread of influenza. Hurricanes swept across the peninsula, surprising newcomers with their forceful winds and rain without warning. Forced to rebuild and replant multiple times, families came and went, but the town continued.

World War II touched every aspect of daily life. Barbara Hammer McCall was nine years old then and recalled in an interview, "I can remember telling Mrs. Jenne at the end of the war that our boys are coming home. . . . My mother [Anna Elida Griffin Hammer] had been upset the whole time my three older uncles, A.D., Carl and Harry John Griffin, were over there. . . . And every time we saw a movie, they would have previews and news and show what's happening in the war and here would come a semi full of troops or supplies and a bomb would fall. It would drive my mother crazy because that's what they were doing. . . . Our boys were in heavy stuff." The war ended, but nature remained relentless, with months of rain followed by two hurricanes that overwhelmed the canal system and flooded the groves and farmland in 1947. Still, the community persevered.

Helen Stirling Gill, daughter of Frank Stirling and lifelong Davie resident, wrote of her experience in Davie: "In spite of depressions, wars, hurricanes, hard freezes and floods, the Davie people prevailed. It is my opinion, we survived because we took care of each other in hard times, and shared as much as we could; we rejoiced with the birth of a new baby and shared in the grief when a friend or neighbor died. Those were simple days and we did struggle to survive, but we were all so much younger then, and dreamed dreams of better times to come, and they did come!"

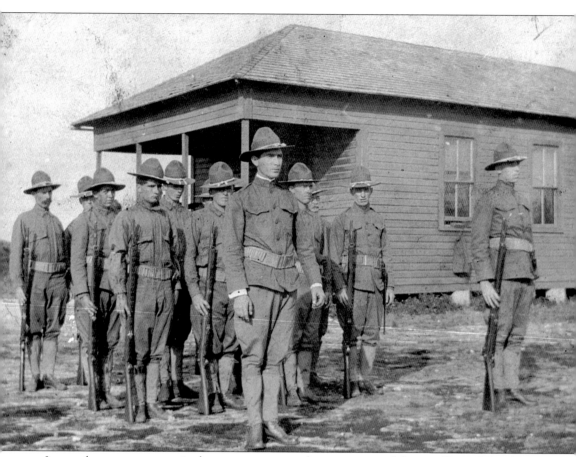

Just as the young community began to prosper and construction of the new Davie School was underway, the United States entered World War I in 1917. Men from Broward enlisted and were drafted across all branches of the military. When the Florida National Guard was called into service in early 1917, the state legislature authorized each county to form Home Guard units to serve as temporary reserve forces and maintain public safety on the home front. Local men serving in the Broward Home Guard are shown standing at attention in front of Davie's two-room wooden school building in 1918. The volunteers trained locally and were provided with uniforms and a gun, though they never participated in any action in Broward during the war.

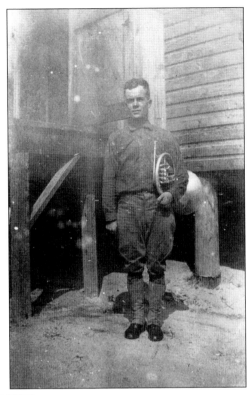

Paul Hammer was inducted into the Army in October 1917 and played the French horn as part of the 324th Infantry Band of the 81st "Wildcat" Division in France. His older brother Ed Hammer served in the Coast Guard during the war. Below, Ralph and Wally Hammer stand beside the blue-star service flag belonging to Adeline Hammer. Introduced in 1917, the flag represented the members of the family currently serving in the armed forces—two stars for two sons in service, both of whom returned safely. However, one soldier from Davie did not return— Marco Salvino succumbed to pneumonia in 1919 in France, where he is buried.

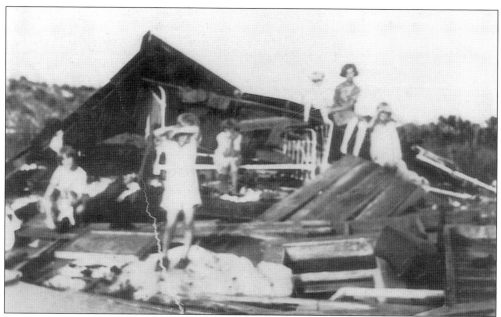

Mary Hammer Lloyd recalled the Category 4 hurricane that made landfall at Miami Beach on September 18, 1926: "I remember a neighbor warned us of the possibility of a hurricane, but we had never seen one and disregarded the warnings as did others in town. When we got up in the morning, the sky was an ugly red and the wind was howling." The storm and flooding devastated farmland and left families homeless, living in Red Cross tents or evacuated to Palm Beach. Here, the Holman family sit on the remains of their Davie home. (Carson family.)

DANCE HELD AT DAVIE THURSDAY FOR RED CROSS

A testimonial dance was tendered local R. Cross officials and workers by the citizens of Davie Thursday night as a mark of appreciation for the relief afforded the citizens and the town of Davie by the Red Cross.

The dance was held in the open under the light of the tropical moon on Winkehake's "floor." Workers and officials of the Fort Lauderdale district said that it was one of the most unique settings of any function ever tendered to their organization in their experience and was an evidence of the spirit of the town of Davie to overcome its disasters.

The "floor" is literally nothing else and is all that is lifet of W. Winkehake's home. Through one of its freaks, the hurricane tore away all of the house, leaving the floor intact and the citizens of Davie have come to call the remnant of the building "Winkehake's floor."

Here, under the full moon, the townsfolk of Davie turned out to make the evening a real social event. A piano was placed on a truck and backed up to the "floor." Light was supplied from a small electrical plant, and the music was furnished by Red Cross workers who took turns at the piano.

Refreshments were served in the relief tent occupied by L. Winkehake throughout the evening.

Frank C. Sterling, mayor of Davie, was general chairman and L. Winkehake headed the committee on arrangements.

The 1926 hurricane ended the Florida land boom and sent the state into a depression. Many families left Davie, and the first incorporation of the town was dissolved. But by December, the community was rebuilding. This article from the *Fort Lauderdale Daily News* describes a dance celebrating the relief efforts that was "held in the open under the light of the tropical moon" on what remained of William Winkelhake's home—only the floor. (Broward County Historical Archives.)

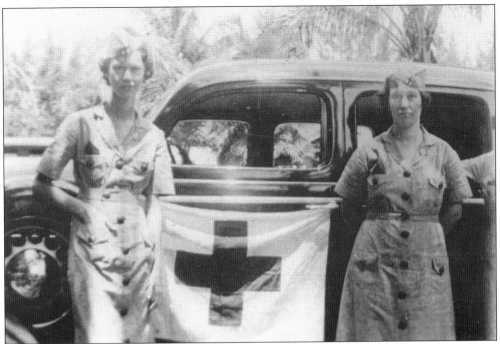

When the United States entered World War II in 1941, the buzz of planes overhead, war bond drives, rationing, and victory gardens became common over the next four years. Men and women from Davie enlisted for service, while families adapted and contributed on the home front, including (above) Anna Elida Griffin Hammer (left) and Martha Rubison, pictured in their Red Cross volunteer uniforms. Built at the Davie Chamber of Commerce building in 1942, the Davie Honor Roll recognized local men who enlisted in the armed forces. By 1944, a third panel was added as men continued joining the fight. Pictured below in front of the sign are Lyda Mae Aunapu (left) and Frances Wabnitz.

My Dear Son Hully;

Today has been a real red-letter day for both Clarella and I received a letter from and it's impossible for me to tell you in words how happy all of us were for it's the first word we here in the office had had from you since your letter to me of Dec.14th. I'm writing you this letter feeling that you will get it before you leave for home which according to your letter you will come about the middle of June.

I want you to know that we all are mighty happy to look forward to seeing you at that time and today when I red your letter to all of the boys on the job they were almost as happy as Walter and Clarella and I were. Dad Spooner says he is going to barbeque a goat and a pig when you come and I am seeing to it that there will be several orange and grapefruit trees full of fruit awaiting you and you alone. I am thankful that your throat trouble is now alright and that you are alright otherwise.

Now for a little local news for I know you want to sort of keep informed as to just what is what here in your own baliwick: First all of us are well and of course buisy.We just got over having a great big Orange Festival like we had last year and we had about eight thousand people come out to see it.Last night Clarella,Jean and I attended a Red-Cross banquet at the Governor's Club in Lauderdale.Walt is buisy on Air Raid Warden work at nights and Clarella is teaching a large First Aid class of thirty men and I am doing just about the things I usually do that is making speaches here and there, one almost every week and enjoying it.I am personally feeling fine. Dr.Wilhelm always speaks of you and the other day he gave me a fine duck which Clarella cooked and Walt and she and I had one of those fine meals which Clarella fixes up.Van is buisy in Chicago and Jean is here and I see a great deal of her and one week she and I had supper four consequtive evenings together. The whole town here at Davie is about the same with a lot of new faces appearing all the time and all the old timers always asking me if I have heared from you for "Old Boy" if I do say it,every body here loves you a lot.I believe I told you that there were over thirty boys from Davie are somewhere in uniform. John Van Kirk has been made a captian and is his dad proud?.You would'nt know the office, we've added to it,made it twice as big as it was,even to a wash-room with all the regular plumbing fixtures. I told you we built a bridge-the best bridge in Davie in front of the office. We have transformed the tank house so that you wont know it. We have built a concrete sea-wall in front of the office. In other words we have gone "high-hat"around here and arent ashamed to have anybody come around. But now listen to this: it'll knock you down: We are building five cottages, nice little cottages (two rooms-sleeping poarch and kitchen) right back of the nursery,near the tractor shed,you might call it "Stirling's addition to Davie and we're absolutely financing the whole works ourself. We're doing it to assure labor for that is our problem and these houses will be shelter for our own men and it will be a good investment no matter what happens and will of course greatly

As an experienced pilot, Hully Stirling, son of Frank Stirling, enlisted with the Royal Air Force in May 1941 before the United States entered the war. He served in the Air Transport Auxiliary of the British Flying Command, a ferry unit flying bomber planes built in Canada to England, Ireland, and Scotland. After the attack on Pearl Harbor on December 7, 1941, Hully's family in Davie had not heard from him in more than three months. After Frank received a letter from Hully stating he would be completing his contract with the Royal Air Force and returning home, he wrote this response in March 1942.

incr ase the value of our property. Now here's something else; you know our
Section 22, the one you and I and Mr.Chaplin have, well the Navy surveyors
have been out there surveying and it looks like our 640 acres might be an-
other large Navy landing field. It wont be the first time it was used as a
landing field for we told them that you parked you little G.B.plane there
and they seemed to know about that too. Boy, the air is full of planes here
all day and at night,it's the same all over Florida, All over the whole U.S.
Dad counted 35 bombers in one bunch today over Sec.14. It seems to me that
with all these fine fellows doing what they are doing all over the country
that Mr.Hitler,Mr.Hirohito and Mr.Mussolini are ultimately going to have a
plenty coming to them.

Hully, the whole energy, the wonderful executive ability and
initative of the United States,with it's tremenduous resources is now going
to town in a real big way, in such a big way that should I tell you what
little I know of the war program under way and should this letter fall in-
to the hands of the enemy they'd sure have a fit when they read it. The
mind of the whole nation is fully made up to finish this thing up in a way
that will settle definitely the way to live, the proper way to live, the
way democracies should live, the only decent way.

So; my boy, I am happy to write you tonight, happier still
to have heared from you today, glad indeed to know that I will see you
this summer, proud as all "get-out" of what you are doing for our allies
and for our own country and for all of your loved ones.

I know you've had some wonderful experiences.Things you will
remember all the rest of your life with pleasure and I still maintain
that you exercised excellent judgment in deciding to do just what you are
doing.

I doubt if any father has cause to be more proud of two sons
than I have. Walter is sure one wonderful brother to you and a loyal son
to his dad. He and I have seemed to have gotten closer than ever since
you have been away and I know that when this "fracas" is over and you de-
cide to again enter into active participation in the firm that we'll roll
along better than ever.

I am making a copy of your letter to me for Helen for I know
she is just as ancious as we are to hear every thing about you.

With a great deal of love to you I am

Dad.

When Hully Stirling returned, he enlisted in the US Navy and served the remainder of the war
stationed in Jacksonville. He was one of many Davie men to serve. The Selective Service required
all men between the ages of 21 and 45 to register for the draft. The Davie School was established
as a registration location by 1942. This letter describes the "whole energy" of the wartime effort
in the community, and the town that would be waiting for the soldiers when they returned home.

Broward Plane Spotters In Action

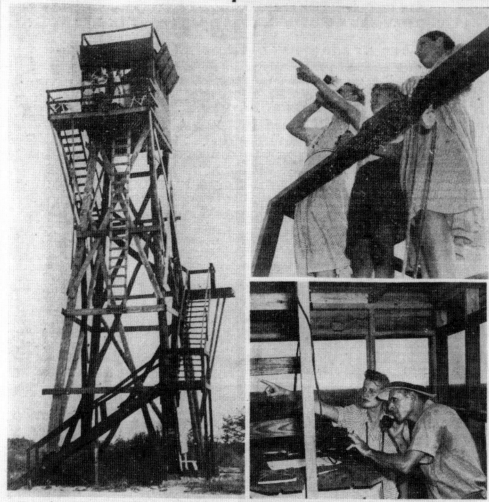

This airplane spotting tower at Davie has drawn the praise of Army officials as a model project. Built entirely by Davie residents of donated materials, the tower is 50 feet high and affords a vision of 20 miles on a clear day. Davie men, women and children man the tower 24 hours a day. In the upper picture, three Davie residents keep a sharp lookout from the top deck of the observation booth atop the tower. Sharp-eyed Dwight Viele, son of Chief Spotter Ed Viele, points out a distant plane to his mother, right, while Mrs. Larry Winkelhake uses her binoculars for a closer look. Inside the observation booth mounted on the tower, Bernadine Wabnitz indicates to Ed Viele the location of the plane reported by the observers on the roof. Viele calls in a description of the plane to the Army central filter station where the report is checked.

When Army officers from Miami wanted to build a watchtower in the area but did not have federal funds available, Davie residents responded to the call. Led by Ed Viele, the Davie air warden and World War I veteran, the town organized by donating materials and building the structure in 1942. The watchtower was built in Wacico Groves near what is now the corner of Ninetieth Avenue and Griffin Road. A group of civilian volunteers manned the watchtower around the clock for the entirety of the war as a part of the Aircraft Warning Service. Women and even children took the day shifts, while men took the night shifts. Armed with binoculars and a telephone, the volunteers would report any planes they spotted to the Army central station, monitoring for the ever-present threat of an enemy invasion. (*Fort Lauderdale Daily News*/TCA.)

In 1940, the US Navy purchased dairy land from Hamilton Forman to use as an auxiliary airfield. By 1941, primary flight instruction began at Forman Field. The wagon-wheel design allowed new pilots to practice landing in any wind. The *Fort Lauderdale Daily News* reported that new pilots would be tossed into the nearby canal after completing their first solo flights. The field turned to advanced operational training by 1942. Pilots learned to fly and land Grumman Avenger TBF torpedo bombers on aircraft carriers and drop dummy bombs on targets in the Everglades. The planes' folding wings maximized space on aircraft carriers, as seen above. After the war, the field was abandoned and used for drag racing until it became the site for the South Florida Education Center in the 1960s.

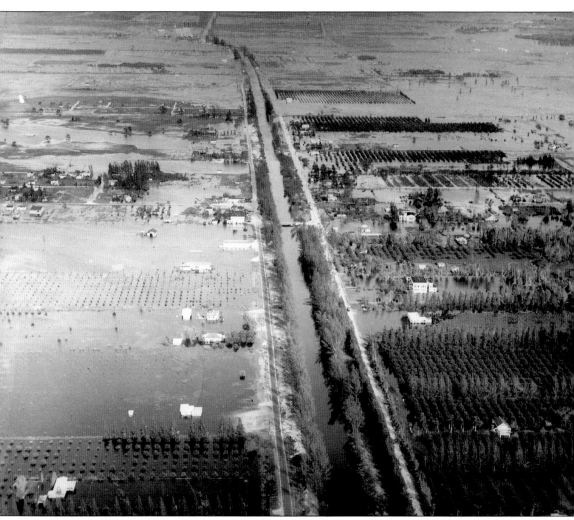

In 1947, months of record-breaking rain threatened the citrus and cattle industries in Davie. Pumps throughout the canal system were flooded and could not move enough water to relieve the overflow. Each rainstorm pushed the town to its limit. Late in the season, a Category 4 hurricane on September 17 made a direct hit on Fort Lauderdale, and a Category 2 hurricane followed on October 12, overwhelming the waterlogged Everglades farmland. Families evacuated as the floodwaters rose over the floorboards of their homes. This image shows the floodwaters looking east from Davie with the South New River in the center, Orange Drive on the north, and Griffin Road on the south. The Davie School and town hall buildings are visible.

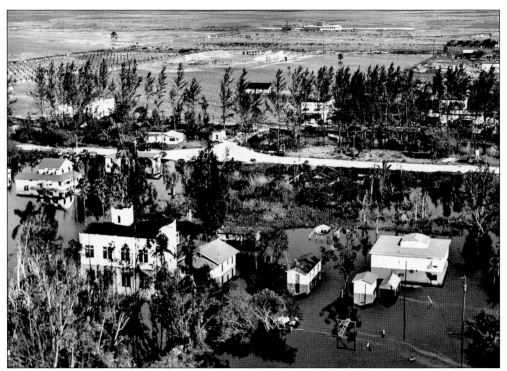

Looking north, this view of the 1947 floodwaters shows the original 1926 Methodist church in the foreground and the Davie Women's Club building (formerly the Lawrence Hotel) to the left. The bridge crosses the South New River Canal, with Anderson's General Store partially obscured behind the trees. The rodeo grounds are in the far background, with Forman Field and its administrative building barely visible. Families like the Lloyds, pictured below in a boat outside their flooded home, evacuated to the dry land at Forman Field. They lived in Red Cross tents on the airfield or in the administrative building until the water receded weeks later and they could return to their damaged homes.

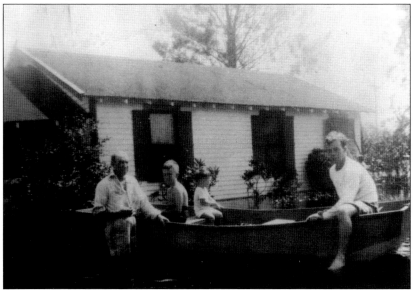

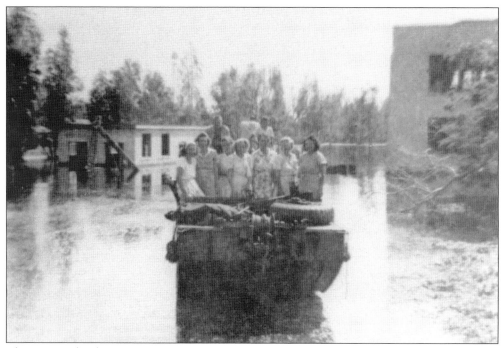

The Davie School was surrounded by water in the 1947 flood, but thankfully, it was spared from damage inside. Local teachers arrived via Army duckboats to rescue books and desks from their classrooms so that they could continue school as best they could for the evacuated families living at the Forman Field site known as Tent City. Davie School teacher Edna Hammer Griffin lived on a boat during the flooding (below). The *Fort Lauderdale News* reported in November 1947: "Many of the residents are still unable to return to their homes. Many are still under water and others are so covered with sediment left by receding floods that they are unlivable. . . . All are determined to remain in Davie and speed the task of rehabilitation." Most of the families were able to return home by mid-December.

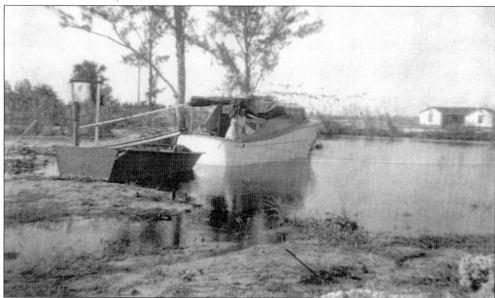

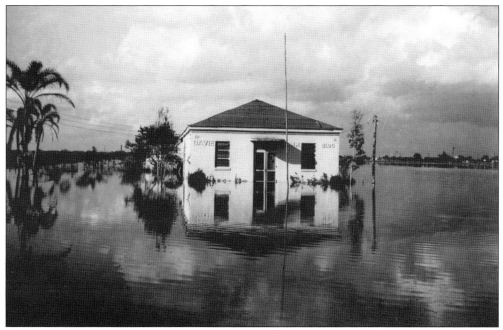

The Davie Chamber of Commerce held a Thanksgiving feast for the community on November 27, 1947, with more than 500 people. Around 300 pounds of turkey were served at the chamber building, which still contained water up until the week of the holiday.

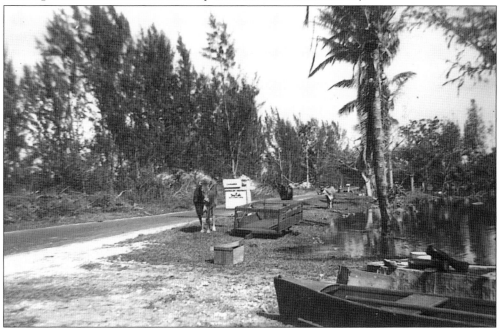

Cattlemen rounded up their herds from the canal banks among the deer, bobcat, snakes, and other creatures seeking refuge from the water on the area's only high ground. Here, cows wander along Griffin Road after the October 1947 storm. More than 1,500 cows drowned, and the damages devastated the beef and dairy industry, forcing ranchers to seek new pastures on drier ground for their surviving cattle.

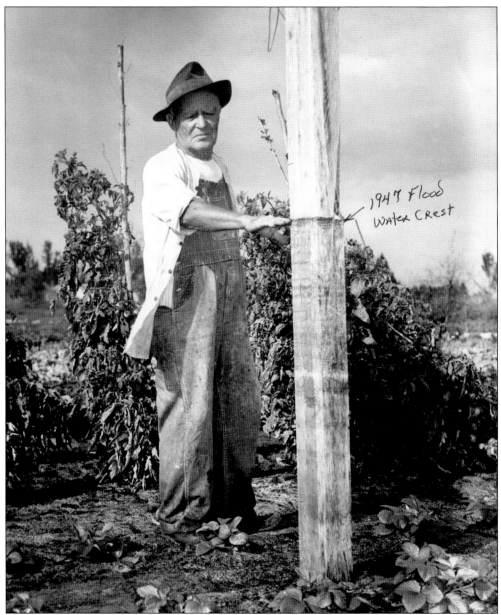

1947 Flood
Water Crest

William Hammer shows the line where the water crested at Stirling Road and US Highway 441. The water sat for six weeks, rotting the roots of the submerged citrus trees and causing millions of dollars of damage and the loss of more than 700,000 trees. Frank Stirling was quoted while sitting in a rowboat reflecting on the $200,000 in damages to his groves: "We old-timers are going to stick here and see this thing through. We're not licked yet and if Davie can be saved or any small part of it, we intend to be here and salvage anything that we can." In response to the devastating consequences of the lack of water control in the reclaimed Everglades, Congress began the Central and South Florida Project. In 1949, the Florida legislature established the Central and Southern Florida Flood Control District to manage the project, which is now known as the South Florida Water Management District. The project brought the US Army Corps of Engineers to build a flood-control system that would attempt to prevent destructive floods in the future.

Ten

A FUTURE FOR DAVIE

In the late 1970s, Davie newcomer Virginia Wagner interviewed her neighbors for a creative writing workshop at Nova University, having them tell their stories of the earliest years in Davie. In 1982, she published "The History of Davie and its Dilemma." The dilemma she presented was,

> As Davie grows, it seeks its own unique identity. Is it a farming community producing beans, broccoli, and roses? Is it a citrus center providing the North with its winter fruit? Or shall its wide fields nourish cattle and its warm climate promote the growth of thoroughbred horses? Shall it be a horticultural center producing the sod and shrubbery for plantings around the great buildings along the oceanfront? Looking toward the future, but with a certain nostalgia for the past, shall it be a western town with rodeos and spirited action? Gazing still farther ahead, shall it become an educational center of such brilliance and originality it will outshine all previous activities? The citizens of the town have not quite made up their minds, though giving the subject very serious thought.

These questions continue into the 21st century in the rapidly changing community—challenging each generation to look back on the "good old days" of Davie and move toward a new future. The farmers who organized in the packinghouse along the canal forged a community with a distinct rustic individuality. The volunteers who built the first rodeo ring laid the foundation for the town's movement to preserve open space. Education has remained fundamental to Davie's story—from one schoolhouse in the Everglades to a renowned university center, and as the heart for historical preservation in western Broward. While some know Davie as "Cowboy Town," the diverse community continues to forge new frontiers while building on its relationship with its past.

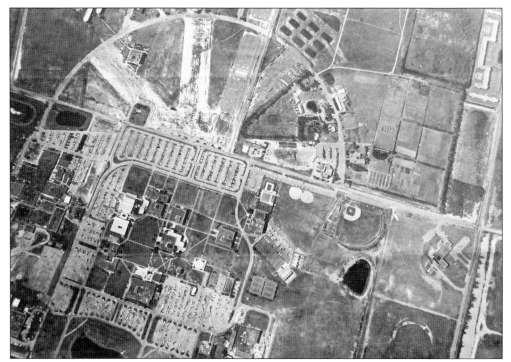

By the 1960s, development of the South Florida Education Center was underway—this would be the future site of Nova Southeastern University, Broward College, McFatter Technical College, primary and secondary schools, and campuses for the University of Florida, Florida International University, and Florida Atlantic University. College Avenue runs north-south through the center of this photograph showing construction overtaking the former Forman Field.

Plans for the South Florida Education Center originated with the Oatmeal Club, a group of south Florida businessmen who would meet for breakfast and to discuss issues and ideas. The group included local Davie men A.D. Griffin and brothers Charles and Hamilton Forman. With a future for education in mind, they incorporated the South Florida Education Center in 1961 with plans to offer postgraduate opportunities in a private university setting. Nova University opened on September 25, 1967.

Founded in 1959, Broward Community College (now Broward College) had its first permanent buildings completed in 1963 at the Central Campus in Davie. The school, originally named the Junior College of Broward County, was included as a part of the growing public and private institutions of the South Florida Education Center.

The innovative Nova High School, a "space-age school" that introduced a nationally recognized scientific method–based curriculum, was dedicated in April 1964. Two elementary schools and a middle school were constructed by the 1970s as part of the South Florida Education Center.

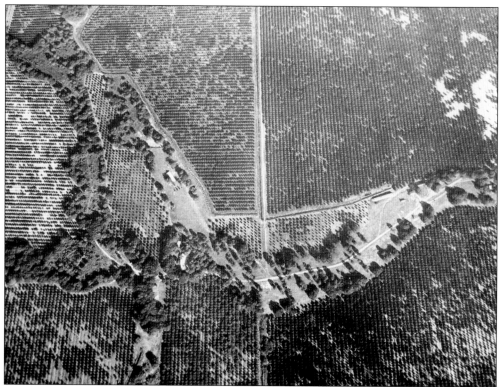

The orange groves and natural spaces of Davie surrounding the Pine Island Ridge, shown above in 1974, were threatened by anticipated development from the east. In 1988, the need to preserve open space was identified with a straw vote—94 percent of voters supported a project to preserve undeveloped property. Voters followed through a year later by overwhelmingly approving the first municipal open-space program in Florida with a $10 million bond referendum to safeguard land from development. The political pin below promoted the successful program during the 1989 election. Today, Davie boasts 1,930 acres of parks and equestrian trails, plus three county parks, including Tree Tops Park, that preserve the natural area of Pine Island Ridge.

The heart of downtown Davie continues to revolve around the rodeo and the Western-themed district. One of the first buildings to redesign its exterior according to the 1980 guidelines for downtown Davie was McDonald's—complete with a corral and hitching post—shown behind Officer LaVerne Fein of the Davie Police Mounted Unit; the specialty police patrol was established in 1984. (LaVerne Fein.)

When students transferred to the new Davie Elementary in 1978, the campus became the South Area offices for the Broward County School Board. Soon after, the site was considered surplus and its fate unknown. Soroptomist International of Davie identified the need to preserve the original 1918 school, forming the Davie School Foundation Inc. in 1984 and rallying support to ensure the future of the historic site. Some of the more recent buildings surrounding the original school were demolished with the expansion of Griffin Road in the 1990s, revealing the 1918 façade again.

In 1984, the first board of trustees for the Davie School Foundation raised support on the local, county, and state levels and honored Davie pioneers. Pictured here are, from left to right, (seated) pioneers Tony Salvino, Alice Woodward, Ed Saar, and Dodge Bernarr Lowe; (standing) trustees Joan Kovac, secretary Mary Ann Taylor, Patti McDaniel, vice chairperson Connie Dickey, Karen Saar Davis, and chairperson Barbara McCall. Treasurer Barbara Spyke and Betty Roberts are not pictured.

The Broward County School Board granted land to the Town of Davie for $1 in 1987. Through the dedicated efforts of Davie School Foundation volunteers, the Davie School was listed in the National Register of Historic Places in March 1988. Early pioneer families participated in the preservation project; here, Ralph Hammer (center), Anna Elida Griffin Hammer (second from right), and Jack Griffin (far right) discuss plans for the restoration with the Davie School Foundation committee.

The Davie School Foundation sought to develop the site into a local history museum. The restoration project uncovered secrets of the building—when the chalkboard was removed, it revealed the original 1918 slate board (pictured above behind Connie Dickey at a foundation meeting). Architect August Geiger's signature keyhole entrance, once squared in the 1960s, was restored as a reminder of the unique beauty and perseverance of building a life on the Everglades frontier.

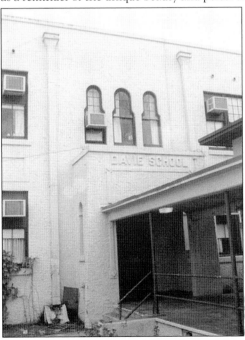

Volunteers undertook the restoration work of the school and grounds. Above, from left to right are Charles Shaw, Richard McCall, Franklin Brown, Dick Postlethwaite, and Clifford Lloyd. The Davie Historical Society worked closely with the foundation, collecting photographs and artifacts of the town and interviewing early pioneers to advise the restoration project and preserve the memories of the town. The foundation's Collections Committee is pictured below. From left to right are Ethelyn Lenz Lloyd, Elsie Scott Pauwels, Enid Hammer Lewis, Rose Marie Thompson Anderson, Barbara Hammer McCall (seated), and Ethel Postlethwaite. In 1999, with support from the Town of Davie, Broward County, Soroptimist International of Davie, and innumerable donors and volunteers, the Davie School Foundation opened the Old Davie School Historical Museum. Now the school continues into a new century, with students, teachers, and visitors once again learning together in the classrooms and building a lasting community on the edge of the Everglades.

ABOUT THE
OLD DAVIE SCHOOL
HISTORICAL MUSEUM

The Old Davie School Historical Museum collects, preserves, and interprets historical objects, and educates people about the heritage, culture, and history of the Davie community and western Broward County.

Today, the Old Davie School Historical Museum offers tours of the 1918 Davie School, 1912 Viele Home, 1914 Walsh-Osterhoudt Home, and more on its historic campus along with programming and archival research.

Old Davie School Historical Museum
6650 Griffin Road, Davie, FL 33314
954-797-1044
www.olddavieschool.org

DISCOVER THOUSANDS OF LOCAL HISTORY BOOKS
FEATURING MILLIONS OF VINTAGE IMAGES

Arcadia Publishing, the leading local history publisher in the United States, is committed to making history accessible and meaningful through publishing books that celebrate and preserve the heritage of America's people and places.

Find more books like this at
www.arcadiapublishing.com

Search for your hometown history, your old stomping grounds, and even your favorite sports team.